MW00532397

THE
HEART
TO
START

ALSO BY DAVID KADAVY

Design for Hackers: Reverse-Engineering Beauty

SHORT READS
How to Write a Book

Make Money Writing on the STEEM Blockchain

THE
HEART
TO
START

DAVID KADAVY

STOP

PROCRASTINATING

& START

CREATING

KADAVYINC.

TABLE OF CONTENTS

BONUS MATERIAL

I RECENTLY REDESIGNED my life to make writing my top priority. As a result, I quadrupled my writing output. If you'd like to learn what tools I rely on, and get further updates from me, please visit kadavy.net/htstools

THE
HEART
TO
START

PROLOGUE

*The first step to controlling your world is
to control your culture.... To write the
books. Make the music. Shoot the films.
Paint the art.*

—CHUCK PALAHNIUK

I'LL START OFF by introducing the elephant in the room:
You don't need this book to get started. If you can put this
book down and start creating your art, then that's exactly
what you should do. Write your first novel, record your first
album, or build your first company. If you're capable of start-
ing now, I hope you're flipping through the first few pages of
this book, and haven't spent your hard-earned cash. It was
nice talking to you, and I'd love to see what you make.

For me, it's never been that simple. I've been an indepen-
dent creator for ten years now, making a living from writing,
podcasting, and teaching what I learn along the way. I still
remember the first time I met a real "starter." He was an older
neighborhood kid who was running a snow removal busi-
ness. As he sipped on a Coca Cola at my high school gradu-
ation party, I couldn't stop drilling him with questions. *How
did you rebuild the engine on that truck? How did you install
the snow plow? How did you find your customers?* He kept

shrugging his shoulders and giving me the same frustrating answer: "I just *did* it."

As I started working for myself more than a decade ago, I was hearing this story, in the form of advice, over and over again. It seemed to be all anyone in Silicon Valley could tell me. There was no end to the number of books I could read, speeches I could watch, or podcasts I could listen to that all told me the same thing: *Just get started.* It's good advice if you can follow it, but I was always left wondering: "Yeah, but *how* do I start?"

IN THE FALL of 2016 I settled into my sound studio and logged onto Skype. As I waited for the call to connect, I took a deep breath to calm my racing heart. I was about to interview one of my heroes for my podcast, *Love Your Work.* Like the neighbor kid, James Altucher is a real starter. He's started more than twenty companies. He's written eighteen books, including the *Wall Street Journal* bestseller *Choose Yourself.* He hosts a top-ranked podcast, on which he has interviewed Coolio, Sir Richard Branson, and Sara Blakely.

I go into each interview hoping to get a superpower from my guest. I wanted to find out how James became so prolific. He seemed like the best person I could ask about starting.

Yet as I talked to James, I grew frustrated. It seemed as if he never struggled with starting. He talked about starting one of his many businesses. He said he simply wrote a short business plan and emailed it to people. I asked him about finding

the courage to share his embarrassing stories online – did he ever worry about what other people would think? He said he didn't. I asked him about whittling his possessions down to fifteen things, throwing away even his college diploma. Did he ever wonder if he was going crazy? "No, never."

I wasn't finding what I was looking for, so I lost my patience. "This is something I want to figure out about you, James," I interrupted. "I think what holds a lot of people back a lot of times is they don't think big. And if they do start thinking big, they start to question themselves. So I'm wondering: Is this an inherent thing to you, or was there any particular period of time where you didn't think that way and you started to?"

James paused for a moment. "I always thought I could do anything," he said. "I was in second grade, writing books that I thought were going to get published and be bestsellers. I always thought that nothing stood in my way."

It didn't look like I would be getting James's superpower. If he always thought he could do anything, what could he teach someone like me? I still had another forty-five minutes with him, so I resolved to dig deeper. "I feel like…a lot of people," I said, "have these little glimpses of ideas or dreams or fantasies in their heads and then it just goes right over them. They don't realize that the thing that they just fantasized about is something that they could actually go ahead and do."

Then James pointed out something that should have

been obvious. "You follow a lot of ideas. You said you're from Omaha, Nebraska. But now you're sitting in Colombia...doing a podcast with me and I'm six-thousand miles from you.... You're doing this amazing science-fiction thing right now.... So let me ask you a question: Did you just suddenly quit your job and move from Omaha to Colombia? Like, what happened?"

James had a point. Here I was grilling him about starting, but I had clearly made many starts myself. I had started companies, written a bestselling book, and started my podcast. Several weeks prior to our conversation, like James, I had also sold all of my possessions. I moved to South America.

UNLIKE JAMES, I did not always believe I could do anything. In fact, it was as if "anything" didn't exist. Growing up, each book I read, each movie I watched, and each Nintendo game I played may as well have been one of the crab apples growing on the tree in the backyard. It was part of the natural environment. It grew from another species. It never dawned on me that these things were made by mortal humans like me. I never imagined that my work could be less like the bleary-eyed, early-morning processions to school and more like the summers I passed drawing or reading in my room. As far as I could tell, it never dawned on anyone in the quiet cul-de-sac where I grew up – except maybe for the kid with the snow plow.

By the time I did realize it was an option to make my

art – whether it was a painting, a website, or a snow removal business – I had decades of mental programming to undo. I had never considered doing anything other than what I was told. It was assumed that I would do my homework and not talk in class and fill out the proper standardized-test bubbles with a No. 2 pencil. Just what all of this would get me was unclear. It wasn't until I found myself sitting in a beige cubicle that I ever thought to ask.

When I did finally start following my own ideas, this mental programming served as walls of a labyrinth of fears and mental distortions. I feared the judgment of others. I doubted my abilities. I struggled with motivation. I escaped into distractions.

I'm sure James has faced these same obstacles to starting, but somehow he has made overcoming them look easy. It reminds me of the motivation for writing my first book, *Design for Hackers*. A friend told me that every time he asked a designer how to make a beautiful website or logo design, he always got a shoulder shrug, and an unsatisfying response: "I guess you have it, or you don't."

If there's something that comes naturally to me, it's being skeptical of "you have it, or you don't." New research in psychology has shown that I'm right. People who believe they can learn, actually can ("growth mindset"). People who don't believe they can learn, struggle to learn ("fixed mindset"). We used to believe that the brain stopped changing at a certain age, but now we know it never stops changing.

I've seen firsthand that people can do things they don't seem naturally inclined to do. Since writing my first book, I've gotten emails from many self-proclaimed "programmer-types," thrilled that they can finally make beautiful designs. One of these emails was even from a color-blind software developer. He had physical limitations to distinguishing colors, but he simply needed to be shown a new way of understanding color. He now makes money on the side from website themes he designed.

IN THIS BOOK, I will deconstruct starting for those who struggle with the advice, *just get started*. Whether you dream of writing a novel, starting a company, or jumping a motorcycle across the Grand Canyon, I'll show you how to find the heart to start.

The first section of the book will introduce you to the laws of art. You feel a force that compels you to make your art, but what forces keep it inside you?

The second section will help you find the fuel. Where can you search for ideas with enough power to keep you moving, even when things get tough?

The third and final section will help you win by beginning. How do you hold yourself back from starting, and how can you overcome those mental barriers to make a start that will propel you through the finish line?

The main thread of this book is my own story. Through a series of short vignettes, I'll take you through how I've over-

come my own fears, doubts, perfectionism, and distractions to start over and over again. I'll take you from Nebraska, to Silicon Valley, to Chicago and Costa Rica, and to where I sit right now, in Colombia. I'll take you through my journey as a cubicle-dweller, to a blogger, to a designer-turned-bestselling-author. Though I've made many starts over the years, the story revolves around what I still believe to be my simplest yet most important start.

Each chapter shows you how other creators and entrepreneurs have used the same phenomena to start. From Evel Knievel to Maya Angelou, from Ed Sheeran to J. K. Rowling, they've all started many times, and they've all overcome the same barriers you and I face. You'll also hear from the podcast guests I've interviewed in more than one hundred episodes of *Love Your Work*, from Seth Godin, from behavioral scientist Dan Ariely, from a Hollywood screenwriter, from a chef, from a creator of a hit board game, and from many others.

With each beginning, there is an end in mind. If you're going to find the heart to start, you need some sense of what it is you're going to start. It might as well be some special thing that nobody else can offer. That's what we'll find in the next chapter.

SECTION I
THE LAWS
OF ART

THERE IS ART INSIDE YOU

*Only put off until tomorrow what you
are willing to die having left undone.*

—Pablo Picasso

T HIS IS GOING to sound crazy, but here goes. It was
September. A crisp wind came in off Lake Michigan
as I stepped into the Lincoln Park Conservatory – a sort of
crystal palace full of tropical plants. The fresh oxygen hit my
lungs. I had taken this walk many times, and it had always
relaxed me, but this time was different. As I walked past the
philodendron and the Manila palm, the muscles that held my
body together melted. Suddenly I felt euphoric, as if I were
evaporating from my own body, the way steam rises from a
cup of oolong. That euphoria then gave way to a strange feel-
ing. Here's the crazy part: I felt ready to die.

I entered a room of prehistoric ferns – delta maidenhair,
the crocodile fern, the heart fern. Apparently many of these
ferns had been around since the dinosaurs. In my oxygen-
intoxicated state, I stared a little longer at the ferns than I
usually did. I felt strangely connected to them.

This was the day after I launched my first book. I awoke

that morning to my phone buzzing on the IKEA-wood-grain laminate of my bed frame. I saw that the call was from Chris, my editor at Wiley, and I did that thing where you're groggy as hell but you try to sound professional. "Bestselling author, David Kadavy!" he said. He had been on a plane from Dubai the day before, so he had missed it all. My book, *Design for Hackers*, had climbed up the Amazon charts. When we had first planned the launch, Chris said it would be an accomplishment for a niche book like mine to make it into the top twenty of the "computers and internet" category. To our surprise, it had made it to number one in that category. Meanwhile, in the "books" category, out of the many millions of books on Amazon, it ranked eighteen.

We were out of books. It was pretty annoying, on launch day, to have a big, orange, "out of stock" message sitting on my book's Amazon page, what with a bunch of people wanting to buy it and all. I was slightly angry about it, but I just listened to Chris as he confidently and deliberately, like an all-star quarterback, laid out his plan for action. They were going to print more books, and the marketing department was going to dedicate more resources, and everything was going to be fine. It was going great. "This is amazing," he added.

As I stared at those prehistoric ferns, I wondered why I couldn't feel this way all the time. I felt transcendent peace. I felt as one with my surroundings. I felt indestructible – not because you couldn't still walk up to me and stomp on my

toe and cause me to hop around on one foot – but because now my existence extended beyond my own body.

I wish I could conjure this same feeling at any other time, but apparently there's no substitute for making my art. I imagine that the success of the book helped, but I like to think that it wouldn't have mattered. Maybe if nobody had bought it I would have felt the same way.

All my life, I had wanted to create. Some people want to be parents. Some people want to make lots of money. I just wanted to make stuff. I had set up all of my life, and I continue to set up all of my life, to prioritize that one thing. No matter how many therapy sessions I spend worrying that it's selfish or egotistical, I ultimately conclude that I don't know any other way. There's this constant gnawing feeling. I feel uneasy, like I've wasted a day, if I haven't created something.

This is why I felt that crazy feeling on this day – the feeling that I could step out onto Fullerton Parkway, and one of those big, nasty garbage trucks with stale pop running down its side could barrel right through me, and somehow, that would be okay. I had created something. It might not last as long as a prehistoric fern, but it was out there – separate from my body. Sure, I had finished lots of smaller things before – a blog post, a logo, an app – but this time, it was different. This book was the purest combination of my passions and interests I could have made at that point. It had been a long, winding, and lonely journey to get here, but I felt I had finally "made it."

WHEN I WAS in fourth grade, my science teacher brought a box full of rubber balls to class. Mr. Landon put us into groups and gave us all meter sticks. My classmate, a sandy-haired, buck-toothed kid named Todd, held the meter stick vertically above the floor. Heather stood by with a clipboard and pencil and coke-bottle glasses, and I held the ball, as instructed, at the top of the meter stick.

Mr. Landon sauntered around the classroom with a knowing look on his face and asked us to drop the ball and measure how high it bounced. I was confused as to why he asked us to drop the ball from the top of the meter stick. After all, these were extremely bouncy balls. I had just seen him bounce one all the way to the ceiling a few moments before. It would be hard to measure precisely how high our ball bounced, I figured, because it was clearly going to bounce higher than the top of the meter stick. But I had once been voted "best behaved" by my classmates. I always did what I was told, so I let the ball drop.

We dropped the ball from a height of one hundred centimeters, and it bounced up to eighty-nine centimeters. Surely something was wrong. Heather suggested we try again. Same result. Chatter spread in the classroom as each group turned to another group. "What did you get? WHAT?!" It was pandemonium. One kid fell to the floor in disbelief. Others were jumping and screaming. If bouncy balls didn't bounce high,

then bouncy balls were a lie. What else was a lie? Our collective fourth-grader conception of reality was utterly shattered that day. We would never be the same.

After Mr. Landon had restored order in the classroom, he calmly explained to us that there are laws that predict how high the ball will bounce. The ball has weight, it falls a certain distance. The ball has a certain "bounciness," that determines how it will react to the force of the drop. By understanding these laws, you understand how the ball will behave. And when you simply drop a ball, it will never, ever – never – bounce higher than the height from which it was dropped.

Just as there are laws that govern how high a rubber ball will bounce, there are also laws that govern whether you will make your art. In the course of our lives, we build kinetic energy. Time goes by, we have new experiences, and we get older. No matter what, we will be impacted by our world. We'll hear the judgements of others, or get sidetracked by distractions. We can let that impact stop us, the way a bean bag would limply plop onto the floor, or we can harness the energy of that impact to help us reach our potential. Moreover, we can reach greater heights by putting in effort.

If you're looking for the heart to start making something, you need to understand what forces hold you back. You need to know how to make the most of life's inevitable collisions. You need to know what you can do to reliably put real effort into your pursuits. It's the difference between flying to the

stratosphere and finding yourself dribbling on the linoleum-tile floor.

This brings us to the first law of art: There Is Art Inside You.

JON BOKENKAMP IS the creator of NBC's hit prime-time series *The Blacklist*. James Spader plays a jet-setting professional criminal who acts as an informant to the FBI.

Jon struggled for years before creating the show. He had some successes here and there, but his phone would stop ringing for years at a time. Still, he kept believing that he had something special to offer.

On my podcast, *Love Your Work*, I asked Jon what advice he had for others who were trying to find their way as creators. He said to remember that "no matter who you are, you really are the only person with that voice. And that is the thing to really lean into, even if it's weird." When Jon's scripts were being rejected, he kept reminding himself of this. He'd say, "I'm going to do my thing. That's the one thing nobody else can do."

It's easy to forget that you have something special to offer the world. We're generally not encouraged to explore our uniqueness. It's been too risky in the past century or so, but moving forward, it may be a necessity.

It used to be that every artifact was made by an artisan. If you had a spoon, an artisan made it. If you had a gun, an artisan made it.

Then interchangeable parts were invented. Now, if your musket broke, you could order a new part from Eli Whitney's factory, and your gun was fixed.

This system of interchangeable parts started to shape the way that people worked together. People had to become interchangeable parts, too. Today, if this regional manager of operations quits, we can replace her with a different regional manager of operations. Both of them have MBAs and have been through the same educational system, so while they may be different in many ways, they're similar enough to replace one another, even if one of them was voted "best behaved" in fourth grade.

This has gotten humanity far. There is still no shortage of great art being made by those who are able to overcome the pressures to fit in. But now we're in the midst of another revolution. Automation and artificial intelligence may soon be able to do the job of a regional manager of operations.

This scares the heck out of a lot of people, but it's actually a great opportunity. Just as agriculture allowed us to spend less time chasing food and more time thinking abstractly, the automation of jobs will move what we call "work" up Maslow's hierarchy of needs. Instead of spending our time and energy on tasks that can be automated, we can reconnect with our humanity – and our humanity is what makes us all artists.

Just like that bouncy-ball, you have the potential to fly right through the ceiling tile. But it will take real effort to

meet that potential. The source of that potential is the art that's inside you.

Not only is it your destiny to get it out, it's also becoming increasingly important for you to be able to find that art and bring it into the world. You'll be all the better for it. You could even say, you'll finally be *you*. This ties into the next law we'll be covering, and why it makes it so challenging to find the heart to start.

ART IS SELF-ACTUALIZATION

We delight in the beauty of the butterfly,
but rarely admit the changes it has gone
through to achieve that beauty.

—MAYA ANGELOU

THERE WAS A short period in my life when I would stare in the mirror a lot. I would examine my cheeks, my brow, the ridge of my upper lip. I would look into my own eyes, and marvel at how green they seemed. I had always thought they were brown.

I didn't do this because I was self-obsessed. I was only twenty-five, so I was prone to that, but no.

It seemed like everything in my life was beige at the time. The carpet in my apartment, the walls, my car. I drove downtown each morning to sit in a beige cubicle, where I would crank out beige floor plans and logos and posters for architectural projects – most of them beige-clad retirement communities.

Pretty regularly, I would be exhausted when I got to work. That was because I was on the phone all night, getting yelled at by my girlfriend. I'd tell her we should sleep on it, maybe

talk about it tomorrow. She'd calm down for a second, and then just start yelling at me again. I don't even remember what these "fights" were about, but I do know that one time she yelled at me for an hour and a half because my mother had sent her parents a Christmas card (and yes, they did celebrate Christmas).

I wasn't living the life I wanted at work, and I wasn't living the life I wanted in my personal life. This wasn't what I had pictured. Before I graduated from college, I had traveled around the country – Seattle, Minneapolis, and Chicago – trying to get a job at a prestigious design firm. I was hoping for mentorship, for guidance, and, most importantly, to get out of Nebraska.

But here I was, back in my hometown, living my beige life.

So no, I wasn't staring at myself in the mirror because I thought I was so good-looking. I was staring at myself in the mirror because I didn't recognize the young man I was seeing. He looked fearless and strong. He was bursting through my skin, as if he were on the cusp of breaking through a straitjacket of chains. It seemed that if I stared long enough, I could become the brave human I saw. After an hour or two, I was exhausted. That was enough staring for the day.

As weak as I was in my daily life, I felt one thing with unshaken conviction, and I felt it more strongly than ever when I stared in that mirror: I had something to offer the world. It didn't matter whether I became famous for it, or if

it made me a million dollars. But I felt, rather I *knew*, that I had something uniquely mine to give – something that only I could do.

But how could I possibly make the leap? How could I go from being this young man trapped in the wrong life, to the bold young man I saw in the mirror? How could I ever find the heart to start?

Looking back, I understand perfectly why I didn't recognize myself. What I saw in the mirror was my true self. But the life I was living didn't reflect my true self.

WHEN WE CREATE our art, it's a process of self-actualization. Your true self is constantly in conflict with the expectations of the world around you. Is it okay to do this? Will this make someone mad? Will I embarrass myself? Will I be stripped of my "best behaved" award?

This internal chatter is powerful, but we're so well practiced in obeying its fears that most of us never even notice it. To find the heart to start, you have to listen to that chatter. Not to heed its advice, but to tell it why it's dead wrong.

I used to have a fantasy. Whenever I was in a quiet library, I'd imagine jumping up on a table, acting like a monkey, screaming at the top of my lungs, then running over to the bookshelves and systematically clearing all the books off of every shelf on the floor. There'd just be mountains of books everywhere when I was done.

Now I know it was my true self causing that fantasy. It

wasn't that my true self wanted to make a scene in the library. It was because my true self was bored and angry. It wanted to protest. It wanted me to stop living my life by the templates others had created for me. This compulsion was more intense in a library, all organized with row after row of books, and with stifling rules such as "don't talk" and "don't act like a monkey and clear all the books onto the floor."

I'm reminded of a story of a young Helen Keller. Blind, deaf, and mute from a childhood illness, Helen started acting out. First she locked her mother in the pantry. Then she locked her teacher in an upstairs room and hid the key. Her father had to help her teacher down through a window.

Later in life, Helen reflected on this as the time when her parents made the decision to educate her. She didn't have the tools to communicate her feelings, and she didn't have words to understand the world around her. All that changed when her teacher, Anne Sullivan, was walking Helen down a path where there was a spout of running water. Miss Sullivan placed one of Helen's hands under the water and signed "w-a-t-e-r" into the other hand.

At that moment, Helen first understood that objects in the world had names. She recalled, "Everything had a name, and each name gave birth to a new thought. As we returned to the house every object which I touched seemed to quiver with life. That was because I saw everything with the strange, new sight that had come to me."

We are the same way. When our true self doesn't get a

chance to follow its desires – when it doesn't get the creative exercise necessary to arm it with a vocabulary in which to express itself – it acts out in strange ways.

These days, I no longer fantasize about dismantling libraries. I've built a life and career in which I get to make my art, and my true inner self is satisfied.

This life and career never would have happened if I hadn't started. I would still be grimacing, trying to put on a straight face in libraries and banks and cafes, trying to fit in while my true self was throwing a temper tantrum inside.

My journey would have been so much easier if I had known from the beginning the second law of art: Art Is Self-Actualization.

The only way to become your true self is to find the art inside you and make it real. Your art is the best expression possible of who you really are. You make art when you take your passions, your interests, and even your compassion for others, and combine them to make something uniquely yours.

SELF-ACTUALIZATION THROUGH ART isn't a neat and orderly process. The doing often comes first. It's only later that you realize what it means. We can see this clearly in Jodi Ettenberg's story.

Jodi was a lawyer. She decided she wanted a break, so she and a friend took a year off to travel. To keep friends updated on their travels, Jodi and her traveling companion started a blog together. Jodi's friend quickly lost interest in writing, but

Jodi found herself wanting to continue. She started writing about the places they were going, the food she was eating during her travels, and her experiences navigating her culinary adventures with celiac disease.

When I interviewed Jodi on *Love Your Work*, she told me that when she first left, she was convinced that she would return to her job. But her friend thought otherwise. "You are one hundred percent not going back," her friend told her. It wasn't until more than a year later, after her friend had returned to work, and after Jodi had extended her trip, that Jodi realized she had created a new career for herself. Jodi's writing has helped thousands of people escape vicariously, plan their travels, and consider their own escapes from their careers in law.

As Jodi's story illustrates, the mere act of making your art can lead to surprising self-discoveries. This is all the more reason to *just get started*. But as we'll see in the next chapter, there is another force that fights to hold the self back.

YOUR EGO FEARS YOUR ART

The Self wishes to create, to evolve. The Ego likes things just the way they are.

—Steven Pressfield

D<small>O YOU REMEMBER</small> how "dating" worked in fourth grade? I do.

I'd ask my friend to ask her friend to ask her if she would like me – hypothetically, of course – if I liked her.

It makes you chuckle, but it's no different as an adult. You swipe right if you like someone, and that person will find out only if he or she swipes right, too. With Tinder, your secret is safe.

Dating services are always coming up with new ways to help you protect your feelings.

When it comes to making our art, we are no different. When you're too scared to start, it's because you don't want to get hurt. You feel love or affection or lust for an idea, but what if it rejects you?

What if your chemistry experiment blows up in your face, or your startup pitch falls flat, or nobody reads your blog post?

Yes, it hurts when your artistic efforts don't live up to your hopes and dreams. But be wary of when fears of this keep you from even starting. Even though your true self is trying to get out, your ego is always there to keep it in check.

Many people think of the ego as being the thing that makes you arrogant. If you have a big ego, you strut around, believing you can do anything.

Have you ever noticed that people with the biggest egos are actually the most scared and insecure?

The ego's job is to protect the self from harm. If you puff up your chest or criticize others, you create a source of protection. If you show that you think you're great, maybe others will believe you. If you say that others suck, then you can convince yourself that you could do better.

SEAN STEPHENSON HAS had to examine his own ego more than anyone I could imagine. Born with brittle bone disorder, he's suffered hundreds of bone fractures in his lifetime. The condition stunts his growth. He's only three feet tall, and his limbs are twisted because his bones can't withstand the tension from his own muscles. He's confined to a wheelchair.

Sean has a superpower. It's that when you talk to him, you can't help but realize the silly limitations you put on yourself. Sean hasn't let his condition keep him from living an amazing life. He speaks all over the world, and helps others overcome insecurity through his therapy practice.

Throughout Sean's life, many bullies and online trolls

have made fun of him as a means of protecting themselves. Sean explained, "Human beings, when we don't feel like we're enough – we will sometimes go to the inferior or to the superior complexes. And bullying is the superior complex. It's trying to generate some kind of strength and power through intimidation, through causing fear in others, through beating somebody down."

Few of us are bullies, but it can be tempting to criticize others. We can't believe someone else would put out such sub-par work. But criticizing others wastes energy we could be using to grow. Sean said, "I've never found a bully that was doing amazing things with their life…. Successful, happy, well-emotionally-balanced people don't have time to shit on somebody else."

Ego doesn't just make you act arrogant or criticize others. Ego also causes you to make excuses for yourself.

Think of ego as a shell that covers up the self. The ego is there to protect the self from the elements in any way it can. It's like Ryan Holiday, author of *Ego is the Enemy*, told me: "The reason ego exists is comfort."

If you put your art out there, it might not be any good. So the ego will come up with excuses to not start. You're still doing research, you don't have the time, or there's a crack on your laptop screen.

Whatever excuses your ego comes up with, they'll never be about you. They'll always be about some outside force. But the excuses really come from inside.

In *The War of Art*, Steven Pressfield called this phenomenon "resistance." In any artistic endeavor, you'll always face resistance.

Sometimes resistance comes in the form of raw fear. But usually, it doesn't. This is because admitting you're scared does too much damage to the self. That's why the ego is so good at coming up with other reasons.

THIS IS THE third law of art: Your Ego Fears Your Art. If you start making your art, you're going to expose your self to discomfort. You'll have to resist distractions to do the work, you'll have to struggle through doing work that doesn't yet meet your standards, and you'll have to face criticism to make your work better. It's the ego's job to protect you from this discomfort.

Over time, the distance between the ego and the self gets bigger and bigger. Then you just have a big pocket of air, with a lot of tension between the shell that is the ego and the little mound that is the self.

Nobody is ever going to have a perfect alignment of ego and self. We're all full of hot air from time to time. This will ebb and flow over our lifetimes. You have to build the skill of recognizing when your ego is taking over. You have to build the skill of fixing it when it does.

YEARS AFTER I was spending all that time staring in the mirror, I was in Silicon Valley. I had started a startup, built

a product, then proceeded to not line up a single investor meeting. Meanwhile, I thought of myself as a "Silicon Valley entrepreneur." I fantasized about raising millions of dollars, filling an office with employees, and taking a company public. Meanwhile, I did nothing toward achieving that vision.

I had already punctured my shell one time to get out of Nebraska, and here I had puffed it up all over again. I had traded the expectations of the cubicle life for the expectations of Silicon Valley. Instead of being a corporate drone, I had to be a renegade. Instead of fitting in, I had to stand out. I bought that every idea worth pursuing had to be world-changing. I bought that you had to build a big company to be considered successful.

When we aren't ourselves, one way our egos can seek protection is through romantic relationships. I found myself in a cycle of compulsive dating. I'd go out with dozens of women, but it never seemed to work.

At one point I had managed to keep some semblance of a relationship going with a woman for about six weeks. Then she broke up with me.

We were still on the phone after she had delivered the news, and suddenly I came to a realization. This life wasn't fitting me anymore. I had been looking for outside approval by seeking a relationship, and I had been looking for outside approval by living according to a definition of success created by others.

Within a month, I shut down my startup and left Silicon

Valley. I ditched my place in San Francisco, and for the same price I was paying for a tiny bedroom in the Mission, I rented a two-bedroom in Chicago's Ukrainian Village. I did everything I could to give myself time and space to explore what interested me. I needed to reconcile this conflict between my self and my ego.

During that time, I had a recurring vision. I pictured a mound of dirt and my hands in the dirt. I even pictured cleaning the dirt from under my fingernails to add it to the mound and make it a teeny tiny bit bigger. I wanted to build upon that mound, to work with what I had, and to do what seemed natural and good to me. Maybe, just maybe, someday that mound would become a hill – or even a mountain.

LIKE ANYONE ELSE, I'm still full of hot air from time to time, but the distance between my self and my ego is thinner and thinner. It's not easy to follow your art. You experience rejection, and judgment from others, and downright heartbreak.

To me, the discomfort you endure pursuing your art is better than being delusional. We used to put several layers of people between ourselves and disappointment when we were courting our classmates on the playground. Most people protect themselves the same way in their work.

It's more comfortable to work where you can blame things that go wrong on a coworker, your boss, your boss's

boss, or even The Board. When you're on your own, you quickly learn that only you are responsible for your own success or failure.

Sure, things might happen that aren't your fault. Your shipment of paint supplies is late, your sous chef calls in sick, or your server goes down. But whether it's your fault or not is irrelevant. You are responsible.

Your ego fears your art because if you follow your art, you will self-actualize. You will become your true self. But to do so, you will experience failure, and rejection, and fear.

This is hard, but it's rewarding. You will finally know the truth. Your ego wants to protect you from harm. That's why it's always telling you that it's not your fault, that you should blame others, or that you should play it safe.

The same way a rocket needs to escape the gravitational pull of Earth to get into space, your art needs to escape the pull of ego to get into the world. You're going to need some serious fuel to make that happen. That's what we'll cover in the coming chapters.

SECTION II
FINDING THE FUEL

CURIOSITY FIRST

*It is good to love many things, for
therein lies the true strength... What is
done in love is well done.*

—Vincent Van Gogh

O N July 18, 2007, I opened my eyes to vastness. I could
do anything I wanted with the hours that stretched out
before me – today, tomorrow, and the day after that. That
was as exciting as it was frightening. It was my first day of
self-employment.

I thought about all the things I had dreamed I could do,
if only I had the time. Well, here was the opportunity right
in front of me. It was as if I had picked a fight with a seven-
foot giant in a bar parking lot, and my buddies who had been
holding me back finally let go and said, "Okay, go for it." The
woolly mammoth of the blank canvas was staring me down.
I could make something great, or I could spiral into playing
Guitar Hero and eating nachos for twelve hours a day.

I needed a strategy to fight against distractions. I needed
a strategy to take my mind off the pressure of finally having a

real opportunity to follow my dreams. The strategy I settled on was simple: Curiosity first.

As I lingered under the warm covers of my bed that first day on my own, I thought back to when I was a child. I would sit in my room alone and draw for hours. My friends in the neighborhood might come to my driveway and yell up to my window and ask if I wanted to play kickball. "No thanks," I would say. I was busy. The time would melt by so effortlessly I would forget to eat.

I figured if I could fill up as much of my day with that feeling as possible – that feeling of "flow" – that would be enough to keep myself motivated. That would be enough to get myself out of bed each day.

YOUR WILL TO start making your art has to fight against everything that tries to hold it back. You may feel like you don't have the time. You may find yourself constantly distracted. You may feel too scared.

But if you have the right fuel, you can bust right through everything. Once you get moving, that fuel can keep you going consistently.

One of the best forms of that fuel is your own curiosity. If you learn how to connect with your curiosity, not only will it propel you through the hard work of getting started, it will be there to keep you moving.

When was the last time you lost track of time while doing something? Maybe you were mixing a song on your comput-

er. Maybe you were having a stimulating conversation with a friend. Maybe it's been different things at different times.

Now imagine turning that activity into your work. Wouldn't work be easier and more enjoyable? Wouldn't you be able to work longer and harder than ever before?

I don't want to create the fantastical impression that you can always be losing track of time while you're doing your work. Bringing your art into the world is always going to be full of uncomfortable moments. Making your art is a job, just like laying bricks or waiting tables.

But think how much easier it is to keep yourself going when you're curious about something.

Lots of people write to me lamenting their "disparate interests." They understand that their own curiosity is powerful fuel, but they are afraid that if they follow their curiosity, they'll never do anything productive.

This is a very natural fear. Ian Leslie, author of *Curious: The Desire to Know and Why Your Future Depends On It*, explained on my podcast that many people resist their own curiosity because once we've reached adulthood, we're encouraged to *exploit* what we've learned. If you have a skill, Ian explained, you can make money off that skill, but you won't learn anything new. You have to find the right balance between *exploitation* and *exploration*.

I ALSO USED to worry whether I would find success by following my curiosity. It was a lesson from Steve Jobs that

helped me trust that it would all work out. Many times during that first year of self-employment, sitting at the shallow desk next to my bed, I watched the video of the commencement address Jobs gave at Stanford in 2005. Every word of that talk gave voice to the feelings that drove me to strike out on my own. It resonated so deeply with me that it brought me to tears. That talk gave me the courage to keep following my curiosity.

"Much of what I stumbled into by following my curiosity and intuition turned out to be priceless later on," Jobs said. He told the story of wandering around his college campus. Because he had dropped out of college, he could drop in on any class he wanted. So he went to a calligraphy class. He learned about the details of drawing beautiful letters. "None of this had even a hope of any practical application in my life," he recalled, "but 10 years later, when we were designing the first Macintosh computer, it all came back to me. And we designed it all into the Mac. It was the first computer with beautiful typography."

I felt that, like Jobs, I was creating my own education by following my curiosity wherever it led me. That first year on my own, I wandered from cafe to cafe, searching for wifi, electrical outlets, and chai lattes. My hard drive piled up with unfinished blog posts and mockups for apps. I remember many dark nights, walking home from a sixteen-hour day in which I hadn't made a dime. The temperate air of San Francisco provided a fitting feeling for my light jacket of satisfaction.

But as my retirement savings dwindled, I often wondered if I was getting off track. Maybe I should stick with one thing?

Whenever I worried, I would return to Jobs's story. Every day, I was learning something new. Even if I wasn't finishing the projects, I was learning new skills with each one. I was also learning what projects could ignite my own curiosity enough to keep me moving, and which ones would quickly lose my interest. It was better than playing Guitar Hero.

CURIOSITY IS POWERFUL fuel for motivation. But curiosity is also a competitive advantage. That's because curiosity will take you places where nobody else can go.

It's a crowded world out there. Sometimes it feels as if every good idea is taken. But if you follow your curiosities, they'll eventually converge into something completely original.

Even if you're not the best in the world at any one of those curiosities, chances are you're the best in the world at your particular combination of curiosities.

When I was a child, as I've said, I loved drawing.

One summer when I was in high school, my brother left his college computer at home, packed in styrofoam blocks in a cardboard box. I took it out, and set it up, and got on the Internet. Those were the days when Steve Case's America Online had these "10 hours free" CDs blanketing the U.S. I even made my first web page on my AOL account.

At the time, the Internet and drawing had nothing to do with one another. "Web design" was limited to making blink-

ing text or plastering a website with animated gifs of comets. But my interest in drawing led me to study design.

My interest in design converged with my interest in the Internet, and I eventually started learning about web design. I was blogging what I was learning along the way. A year after starting my blog, I got a job in Silicon Valley, which was my first contact with entrepreneurship.

When I started my journey of self-employment, I kept Steve Jobs's calligraphy story in my mind. I did exploit my knowledge by doing a little freelance work to pay the bills, but I still made sure to fill up as much of my day as possible with exploration. I trusted that if I followed what I was curious about, it would lead to something interesting.

After three years of experimentation, my biggest curiosities finally converged. My first book, *Design for Hackers*, was born from a combination of my interests in design, programming, entrepreneurship, and writing.

Yes, there were books out there about design principles. But they were written for people who wanted to be graphic designers.

Yes, there were books out there about web design, specifically. But they were written for people who wanted to be web designers.

Because I had experience as an entrepreneur surrounded by programmers, I discovered a gap in the market: Lots of entrepreneurial programmers (who affectionately called themselves "hackers") wanted to learn design not as a profession,

but as another skill to add to their repertoires. They wanted to understand what makes the design of their favorite apps beautiful and functional, and why they struggled to get the same results with the apps they were building.

I had the knowledge, and I understood the audience. I could speak their language, and I wasn't just a designer and an entrepreneur – I had also spent six years writing on my blog, learning how to communicate ideas in an engaging and clear way.

When *Design for Hackers* debuted, it outsold the latest book by U.S. Vice President Dick Cheney. It outsold *The 4-Hour Work Week,* by Tim Ferriss, the author who had inspired much of my journey. It even outsold Eric Ries's *New York Times* bestselling *The Lean Startup*, which debuted on the exact same day.

In the crowded world of web-design books, there's not another book out there just like *Design for Hackers*. The book was only possible because I had followed my curiosity. If I had concentrated only on being a designer, I wouldn't have had the technical know-how to communicate to programmers, I wouldn't have had the entrepreneurial background to understand the audience, and I wouldn't have had the writing skill to communicate it all in a clear and engaging way.

I DON'T HOLD any illusions that writing that book compares in scale to what Steve Jobs accomplished after dropping in on that calligraphy class. I didn't build a company that would

reinvent the world or approach a trillion dollars in value. That wasn't what I was going for. What I did do was find the right combination of exploitation and exploration. I gave myself as much time and space as I could to follow my curiosities.

When Steve Jobs started building the Mac, nobody was thinking about beautiful typography. They were just focused on building computers.

When I was a graphic designer, most graphic designers resisted learning how to program. Few of them were thinking about entrepreneurship, and almost nobody was thinking about combining those things, *and* working hard on writing about it clearly.

If you're looking for the fuel to get started, there's no fuel more powerful than your own curiosity. Following your curiosity can be scary, but if you give yourself space and time, eventually curiosities converge. Then you become untouchable.

Even if you have enough curiosity to fuel a strong start, things will go much better if your ideas resonate with someone else. Next, we'll talk about a fuel source that can help your ideas spread like wildfire.

THE VOICE

If you simply try to tell the truth
(without caring twopence how often
it has been told before) you will, nine
times out of ten, become original
without ever having noticed it.

—C.S. LEWIS

WHAT DO ELVIS Presley, the Impressionist painters, and Harry Potter have in common?

Yes, they're all cultural sensations that came out of big ideas. But almost every big idea does the same thing: Big ideas tap into the collective consciousness. Fortunately, your own consciousness is part of the collective consciousness.

As society progresses, a vacuum grows between the status quo and the true desires of people in the world. The more distance that grows between what people are really thinking and what is actually going on, the more powerful that vacuum becomes. Seth Godin talked about this in more detail in his book *Unleashing the Ideavirus*: If something is going to go "viral," he explained, it has to puncture a "vacuum."

Maya Angelou used to say that the best compliment she

received was when people came up to her and said, "I *wrote* your books last year...I mean I *read*...." To her, that meant she had tapped into their thoughts so well, readers thought the stories were their own.

Have you ever had a friend share an article with you and say, "I *thought* this so many times but I never put it into words"? Have you ever noticed comments on the YouTube video for your favorite song – everyone saying that the song says exactly what they've always wanted to say? This is what happens when you puncture a vacuum. You tap into the thoughts of not just one person but many people. All that pressure propels your idea. It makes people share it.

THERE'S A CONSTANT tension between the way things are, and what's really on the minds of people. Most people don't even notice the chatter going on in their heads. But when you echo that chatter, people notice. Your idea punctures the vacuum.

So when viewers of *The Ed Sullivan Show* grew tired of watching the Everly Brothers rocking back and forth with their guitars and crooning softly, and Elvis Presley came on howling and swinging his hips – that punctured a vacuum and rock and roll was thrust into the mainstream.

When everyone at the Salon de Paris grew tired of seeing yet another polished painting of Venus, and Manet showed up with a seemingly half-finished picnic scene, that punctured a vacuum and Impressionism was born.

When the dawn of the age of reality TV had kids fantasizing about becoming famous for no particular reason, and then a book came out about a boy who suddenly discovers he's a gifted wizard, that punctured a vacuum and turned J. K. Rowling into a billionaire.

It's impossible to predict exactly when a vacuum is ready to be punctured. Too early, and people aren't ready for it. Not enough people are thinking that thing, so the thing is either taboo or too weird. Too late, and the vacuum has already been punctured or deflated.

But there's one compass that always has potential to lead you to an explosive idea: The Voice.

THE VOICE IS in your head all the time. It's in all of our heads. It's constantly chattering, saying things like, *What if luggage had wheels on it?* or *What if you could order groceries through your smartphone?*

Most of us neglect The Voice. We've been taught to fit in and maintain the status quo, so The Voice is a liability. It could get us into trouble.

Most of us neglect The Voice, so we can't hear it. That's why your friend feels compelled to send you that article. She's been thinking the same things, but in that vague, neglected Voice language, which is as unintelligible as an adult in a *Peanuts* TV special.

When you see a great idea, you may smack your forehead and say you wish you would have thought of it. Oftentimes,

you *have* thought of it. You just didn't listen to The Voice carefully enough.

I've learned over the years to remind myself to listen to The Voice. I've had too many forehead-smacking moments in my journey as a creator. I thought about self-investment for years before I blogged briefly about it in 2008 – five years before James Altucher wrote the hit book *Choose Yourself*. I built a Facebook app with a button that strikingly resembled Facebook's own "like" button – a full year before they started using it on their platform. I built a food photo-sharing app months before Foodspotting was built – OpenTable ended up buying Foodspotting for $10 million.

I'm not saying that someone stole my ideas, or that my ideas were anything special. They were in my mind, and at the same time, they were in the minds of hundreds or millions of other people. People around the world are always coming to the same conclusions at the same time. Charles Wheatstone and Samuel Morse raced to invent the telegraph long before they knew one another existed. Joseph Swan and Thomas Edison simultaneously invented the light bulb. Several mathematicians invented calculus at the same time, and every human culture on the planet invented spoken language.

WHETHER OR NOT someone lives on to be known as the person who invented something depends upon too many factors to have complete control over the outcome. But one

factor is absolutely critical to doing something notable: You have to listen to the voice in your head and pursue its ideas.

As you can see from my own experiences, not every idea is going to work, but if you keep listening to The Voice and you keep rolling the dice, you're going to come up with some winners. The winners are what people remember. Keep pursuing the ideas The Voice gives you, even if most of them may not work out. It's better to be right one time out of a hundred than to be right zero times out of zero.

As you look for ideas – ideas with the fuel to get you started – be aware of The Voice. If you pay enough attention to it, if you take the time to interpret the soft whispers of The Voice, you'll find ideas that will motivate you to keep moving. You'll make more of those ideas a reality, and they'll make an impact.

Tapping into the collective consciousness with the help of the voice in your head is a source of powerful ideas, but what you feel in your body when you create can also be a fuel source that helps your art connect with someone. We'll talk about that in the next chapter.

GO FOR 'THE PUMP'

The opposite of art is not ugliness, it's indifference.

—ELI WIESEL

I'VE MADE IT so nearly every day of my life is the same. I eat the same foods. I follow a strict workout schedule. I even live near the equator, in Colombia, where the sun always sets and rises at about the same time. Medellín is known as the "city of the eternal spring," so the average temperature year round is literally the perfect temperature: room temperature.

Each morning, I do the same thing. I put on my "uniform": lightweight athletic shorts and a tri-blend T-shirt. I sit on two pillows on the floor, and I meditate for fifteen minutes. When the timer goes off, I walk to my desk, which faces a blank white wall in a little cove in the corner of my living room. I put in earplugs, I take a moment to focus my mind, and I put my fingers on the keyboard.

Most people think that my routine is mind-numbingly boring. When I wrote about it online, one guy commented, "Relax, man! You need a beer." It's not that I don't enjoy va-

riety – after all, I've lived in about a dozen cities in my lifetime. It's that having this uniformity keeps me from being stimulated by anything that is not my creative work. I won't fool myself into thinking I had a productive day because I was busy deciding what to eat for breakfast, or having coffee with someone randomly introduced to me. I don't eat breakfast, and if I'm going to meet someone for coffee, it will be on Saturday at 3 p.m. at my favorite cafe. Nothing interferes with my morning routine.

This monotony helps me be more sensitive to the thing I'm looking for: I'm looking for "The Pump."

THE PUMP IS a sure way to power through the start of a project, and if you get good at sensing it, it can also keep you going when things get tough.

The Pump is a lot like it sounds. As I'm tapping out those first few words, which sometimes feels like cranking a bike with a rusty chain, I'm listening for the pumping of my own heart. It could be that I'm really excited about an idea. It could be that I'm scared. Whatever I'm feeling, my heartbeat will change accordingly. Sometimes I can feel it pound through my chest. That's when I know I'm really onto something.

I look for The Pump because I've learned that if an idea makes my heart beat harder, two important things will happen.

First, just as water pressure powers a lawn sprinkler, it's as if the pressure of my own blood powers my fingers. When

I really get in touch with The Pump, writing comes much more easily.

Second, I believe my readers will feel what I feel. If I feel The Pump, they'll feel The Pump.

In his book *On Writing*, Stephen King says writing is telepathy. In case you think he's gone cuckoo, he explains that he's writing in December 1997. It's a snowy morning, his wife is sick with a virus, and he has Christmas on his mind. Yet you're reading the book years later, and he's creating images in your head.

Many techno-optimists dream of us one day having brain-to-brain connections. I could have a thought, and that would cause you to have the same thought. But we already have this technology. Writing is just one way of doing this. Each word represents an idea or a thing you can put in someone else's mind.

But I'll take Stephen's description one step further: Not only is writing telepathy. Art is telepathy.

This is why that song moves you so much. This is why you can't put that book down. This is why you feel compelled to volunteer for that nonprofit. Someone created something, and it made you feel something. The communication isn't always as literal as words. Sometimes it's as simple as what that person felt when he or she was making that thing.

That's why it's not just important to connect with The Pump to know when you're onto a good idea. It's also impor-

tant to get yourself into the right mood, so you can transfer
that feeling to your audience.

ANDREW JOHNSON IS a gentle, soft-spoken man who lives
on the northwest coast of the United Kingdom. He commu-
nicates telepathically with millions of people. I'm one of his
receivers. After my morning writing session, followed by a
midday workout and lunch, I lie down on my bed, I put on a
sleeping mask and noise-canceling headphones, and I listen
to Andrew's app, "Relax."

I'm not a natural when it comes to taking naps. If I try
to nap for twenty minutes, I'll spend twenty-two minutes
frustrated that I can't fall asleep. Andrew's voice guides me,
step-by-step, into a relaxed state. When I first started using
Relax, my jaw would flap open and shut – my jaw muscles
had apparently been incredibly tense for years, and they were
finally relaxing!

Now that I've been using Relax for years, I don't even pay
attention to what Andrew is saying, but it still works every
time. Even if I don't fall asleep, I end my session feeling rested,
refreshed, and ready to take on my afternoon. It's no exag-
geration to say that Andrew's app has changed my life. I'm
very grateful for what he's made.

When I interviewed Andrew for *Love Your Work*, it was
no surprise to me that Andrew uses telepathy in his record-
ing process. He had been practicing hypnotherapy for more
than a decade before he created Relax. He was well practiced

in connecting with his clients, but the recording process was another story. "When you see a client," he said, "you just switch off from absolutely everything else…. That's quite easy to do when you have a human being sitting across from you, but not when you've got just a cold microphone and you've still got to create that intimacy."

That's why Andrew goes for The Pump when he gets ready to record. He wants to make sure he's feeling what he wants his listeners to feel. He said, "Over the years, there's been a number of occasions where I've set everything up and it hasn't been right." So Andrew puts extra care into his recording routine. He puts on the most comfortable clothes he has, he closes the curtains over the windows of his home studio, he sits down in an extra-comfortable chair that he's selected just for recording, and he slips the hood of his sweater up over his head. He even records by candlelight.

WHEN YOU'RE TRYING to get started, it can be easy to get too focused on producing the work. Pushing keys on a keyboard or sitting in front of a cold microphone can feel far removed from what the experience will be like for your audience.

In my years of creating, I've learned that The Pump can come with almost any mood. Whether an idea makes me angry, inspired, or sad, I can feel the difference in the way the blood pumps through my body.

When you're looking for the fuel to finally get started, you

can easily miss out on The Pump. You can get overstimulated by things that have nothing to do with your work, and you can wind up pursuing an idea that won't keep you moving. Or, the very act of making your art can keep you from getting into the right mood.

When you set up to create your art, make sure you're in touch with how you feel in that moment. Is your idea giving you the feeling you want your audience to have? If not, is there something you can do to get yourself into that mood? If you listen for The Pump, you'll connect with powerful ideas, and the feeling will be contagious.

Besides your curiosity, the voice in your head, and the feeling in your body, there's one more powerful fuel source for finding the heart to start. Not only will it get you started, but it will also pull you through to the finish line.

THAT WHICH PULLS YOU THROUGH

Real courage is when you know you're
licked before you begin, but you
begin anyway and see it through no
matter what.

—HARPER LEE, *TO KILL A MOCKINGBIRD*

WHEN I WAS writing my first book, I made sure to connect with The Pump and get myself into the right mood for my writing sessions. I remember many lamplit evenings, while the wind rattled my windows and brushed the glass with snow. I'd be kneeling on the hardwood above a sticky-note-covered whiteboard, books splayed open and strewn about the floor and a cup of gyokuro by my side, and I'd think: *This is perfect. I was made for this.*

But as the night wore on, the pressures of my reality would set in. My personal life was in shambles. I had been dumped by a woman I was in love with. I was heartbroken and didn't have the bandwidth to fix it. I had a contract and deadlines, and an advance I would have to return if I got

off schedule. I had no experience writing anything near the length of a 300-page book. The writing process was overwhelming, and it drowned out everything else in my life. At least I had friends, but I had no time to see them.

A ritual I turned to during that time was nightly hot baths. I had fifteen minutes with my thoughts in the candlelight before it was time to go to bed, so I could wake up and do it all again. This was when the loneliness, the heartbreak, and the raw fear of facing this beast of an opportunity would close in on me. Every choice I had made in my life converged in this moment. I had left my lifelong home. I had fled Silicon Valley in the midst of a boom. I had turned down job offers and clients. I had followed my curiosity past a parade of naysayers. This had to happen. I had to finish this book.

Over the dripping of the faucet, the lyrics of a song repeated in my mind. It was by a band named Stars. These lyrics kept me going each night as everything else made me want to quit: *Live through this, and you won't look back.* I knew that if I could finish this book, everything would change. It was the elusive finish line I had been running toward my entire life.

A READER ONCE asked me how I managed to write that book, with no experience writing anything longer than a 2,000-word blog post, in only six months – about half the time one would usually take to write a book of that length. Even with more writing experience under my belt, I'm confident I couldn't repeat that performance today. I had a strong

force propelling me forward. It's called That Which Pulls You Through.

That Which Pulls You Through is the thing that is so strong it can fuel you through the inevitable discomfort of making your art real. No matter how much you love your craft, there are going to be times when you feel as if you can't possibly make it to the next level. Some goal or opportunity is right in front of you, and you can't seem to muster the will you need in order to make it. As your ego cloaks the path to self-actualization with shadows of doubts and fears, That Which Pulls You Through is there to light the way.

J. K. Rowling once recalled that, as she was writing the first *Harry Potter* book, she experienced the death of her mother, divorce, unemployment, and clinical depression, and she even considered suicide. "Rock bottom became the solid foundation on which I rebuilt my life," she said.

As your doubts and fears are in a free fall, That Which Pulls You Through is the solid ground there to collect them all and say "No. I won't accept that. This is going to happen."

That Which Pulls You Through will help you persevere through the tough parts, but it can also be the fuel to get you started. Elise Bauer was fighting a mysterious illness. She had a flu that wouldn't go away. She was in bed for months. If that wasn't enough, her close friend and roommate died of cancer. Elise had had a promising career in tech – she had worked at Apple – but now she had spent much of her life's savings trying to recover from this illness. She had to leave San Fran-

cisco and live with her parents at the age of forty-two. "I felt like a complete failure," she told me when I interviewed her for *Love Your Work.*

But Elise was able to pull through. Her parents were great cooks. As Elise regained her strength, she helped out in the kitchen. She started posting the recipes online, in hand-coded HTML pages.

Elise started getting better, but then she suffered a relapse. She used those recipes to keep going. She told herself: "I'm just going to keep my mind focused on everything that is good and joyful and loving and wonderful in this world and in my life, and see what I can do to bring some of that to other people."

Today, Elise's recipe site, Simply Recipes, is one of the most popular recipe sites on the Internet. She has personally posted more than 1,600 recipes on the site, one by one. And the illness that kept her in bed has long passed.

When you're looking for the heart to start, That Which Pulls You Through might not immediately be clear. Maybe it will get you started, like it did for Elise Bauer, but you might not find out what it is until the going gets tough. When things aren't going your way, pay close attention to the things you tell yourself to keep moving. The more in touch you are with That Which Pulls You Through, the stronger the fuel you can find to get started and the steadier you can be throughout your journey.

It might seem as if That Which Pulls You Through has to come from a painful experience, but it can also come from generosity. As author Seth Godin told me, "Generosity is an excellent antidote to fear. If you're doing this on behalf of someone you care about, the fear takes a back seat." Notice that Elise Bauer wasn't simply reacting to her illness. She wanted to take the good things and "bring some of that to other people."

As I said, I probably couldn't repeat the performance of writing my last book. I'm not going through that kind of pain, and a decade as an independent creator has hardened me: I'm not as afraid of embarrassment. But I still have something to pull me through. Throughout writing this book, whenever I've thought for a moment that it was too hard, or not worth it, I've remembered the twenty-five-year-old who didn't recognize the person he saw in the mirror. I remember how close he came to not following his dreams, and I'm quickly filled with an urgency to prevent anyone else from making the mistake he almost made – the mistake of never even starting.

Throughout this book, we've learned about the forces that threaten to keep your art inside you, and we've found many sources of fuel that can kickstart your journey and keep you going to the finish line. In the next section of this book, we'll look at the many final mental obstacles that can keep you from finding the heart to start, and learn what you can do to overcome them.

SECTION III
WINNING BY BEGINNING

THE FORTRESS FALLACY

To accomplish great things, we must dream as well as act.

—ANATOLE FRANCE

WHEN I WAS ten, I told my mother I was going to write a book. My mother slipped her electric typewriter out of its plastic cover, placed it on the end of the dining room table, and silently left the room.

"Once upon a time," I wrote. I stopped to think of what to type next. The weight of this herculean task bore down upon me. I pictured a giant stack of paper smacking down onto the white tablecloth. That would be what, a *hundred* pages? And here I couldn't get past the first page. Heck, I couldn't get past the first *line*. Suddenly, the idea of playing with blocks sounded more appealing. I quietly hoisted myself down from the chair and abandoned the whirring typewriter.

Years later, I still make this same mistake from time to time, and I see it in nearly every aspiring creator that I talk to. When we set out to do something, we naturally picture something big and grand, even if we have no experience at all.

I call this the Fortress Fallacy, because it's as if we imag-

ine that we will build a giant fortress when we've never laid a single brick in our lives. We want to open a Michelin-star restaurant, but we still haven't gone past microwave nachos. We want to write a novel, but we've never written anything longer than a quick email. We want to direct a feature film, but we've never tried anything beyond posting a video of our cat on Facebook.

As a result, one of two things happens: Either we do nothing more than fantasize, and never start, or we do start, but we lead ourselves into burnout.

When we fantasize about the fortress in our mind, we can actually get pleasure out of it. This becomes a source of procrastination. If we believe we're going to make a grand masterpiece, we can justify not starting. Our egos will fool us into thinking that we need to do more research, or that we just need to carve out a few months of free time to rent a cabin in the woods. Meanwhile, we live inside the dangerous joy of our daydreams.

When we charge head first toward building the fortress, we burn ourselves out. We may be inspired and energized for a few minutes, a few hours, or maybe even a week, but we quickly realize how far we are from achieving the vision in our mind. We've started once, but we'll never start again.

This is exactly what happened when I sat down to write that book. Other than writing that had been assigned for school work, I had never tried to write something. By trying to write an entire book, I not only set myself up for an impos-

sible goal, I also *punished* myself for trying to write. I learned to associate writing with failure.

As a result, it would be fifteen years before I would ever try to write something voluntarily again. Instead, I resorted to fantasizing about what I *might* do if only I had enough time to do something big.

HUGH MACLEOD WAS able to overcome the Fortress Fallacy. He was working in advertising in Chicago in 1997, and after work, he'd go to a cafe and sketch in his notebook. One day, he forgot his notebook. All he had was business cards, so he started sketching on the backs of them.

As it turned out, business cards were the perfect medium for Hugh. He soon moved to New York, and since he was living out of a suitcase and walking around town, the business cards were little pieces of art, the perfect size for Hugh to carry around with him.

Sketching on business cards made creating his art more manageable for Hugh. He told me on *Love Your Work*, "I could do the business-card thing outside of my job, without it bleeding into my existence, whereas if you're a sculptor, that takes over your life."

Hugh eventually started sharing his business-card cartoons online, and they took off. Under the brand Gapingvoid, Hugh has grown beyond business cards. He's done custom artwork for companies such as HP, Microsoft, and Volkswagen, his artwork is hanging in more than 5,000 companies

around the world, and he's illustrated an entire book for Seth Godin.

EVEN THOUGH I made the mistake of trying to build a fortress when I was ten, I eventually stopped fantasizing and started again. I did it by accepting that I wasn't going to achieve the vision in my mind right away. Back when I was staring in the mirror so much, one day I finally took action. I had been inspired by great blogs that were popping up around the Internet, but I had been too intimidated. I imagined building a blog just as sophisticated. I finally overcame the Fortress Fallacy and started with a simple blog post on Blogger. That led to another blog post, then another, then another. It wasn't until later that I started hosting on my own server and redesigned my blog. Six years later, I was writing a whole book.

Dreaming beyond your abilities can be a valuable motivator. The legendary stunt performer Evel Knievel built his career on a big vision. Every chance he got, he'd tell people that he was going to jump over the Grand Canyon on a motorcycle. Meanwhile, he'd jump over rows of trucks or over the fountain at Caesar's Palace. Throughout his career, he used his dream as a landmark on the horizon. He became a cultural sensation and made millions of dollars – even though he never did jump over the Grand Canyon.

To overcome the Fortress Fallacy, all you have to do is recognize that you tend to dream beyond your current abili-

ties. Don't let your own dream intimidate you into not start-
ing, or lead you into burnout when you do start. Instead, like
Evel Knievel's dream of jumping over the Grand Canyon, let
your dream be a guide. Like Hugh MacLeod's business-card
doodles, start small, and over time, you'll build closer and
closer to that dream. Dream of a Michelin-star restaurant, but
start with a dinner party. Dream of a novel, but start with a
short story. Dream of a feature film, but start with a short film.
Instead of building a fortress, start with a cottage.

We don't just dream beyond our abilities. Sometimes we
also exaggerate how much time we need in order to get start-
ed. This makes us procrastinate throughout our lives. In the
next chapter, we'll learn how to find the time to get started
– even when it seems impossible.

INFLATING THE INVESTMENT

*We are cups, constantly and quietly
being filled. The trick is, knowing how to
tip ourselves over and let the beautiful
stuff out.*

—RAY BRADBURY

A COUPLE OF years ago, I was hooked on Facebook. I might have enjoyed seeing what was going on with my friends for a few minutes a day, but just touching my phone would quickly spiral me into compulsively scrolling through the news feed, sometimes for an hour or more, getting no enjoyment out of it at all. I would even say to myself out loud, "Why are you doing this? You don't want to be doing this. Stop!"

When I could finally pull myself away, I'd feel drained. I'd been giving myself tiny dopamine hits, like a lab rat with his brain wired to a switch. I wasn't building toward a long-term reward. It was as if I had eaten cotton candy for breakfast, and now I was crashing from my sugar high.

I didn't want to be spending so much time on Facebook. Instead, I wanted to be writing books, like this one. I knew

something had to change when I was at a cafe on my laptop, trying to write a blog post. I tried to escape Facebook by opening a new tab on my browser, and on that new tab – I went to Facebook.

Later that week, I was at a cocktail party in New York, where I fortunately kept myself from scrolling through Facebook to avoid mingling. That's when I met Museum Hack founder Nick Gray. He told me something that would help me hijack my Facebook habit with a better habit. He said that every few weeks, he'd check out a bunch of books from the library and lay them out on his coffee table. He'd pick one up, flip through it a bit, and, if he got bored, he'd pick up a different book.

Just picturing having a pile of physical books in front of me, I could feel a spark in my mind. I knew this was going to help me kick my Facebook habit.

I know now that, when it came to the things I *wanted* to be doing, I was Inflating the Investment. If I wanted to be writing, it was too easy for me to assume that it would be a big commitment to begin writing. If I wanted to be reading, it was too easy for me to assume that it would be a big commitment to begin reading.

Inflating the Investment is kind of like the Fortress Fallacy, but on a microcosmic level – except that when you Inflate the Investment, you don't intimidate yourself into not starting, or lead yourself into burnout because you're picturing a project beyond your abilities. When you Inflate the In-

vestment, you prevent yourself from starting in the moment because you assume it's too big a commitment. You assume you don't have enough time. As a result, you cause yourself to procrastinate with something that's a smaller commitment.

IMAGINE YOU'RE WAITING to see the dentist. Your appointment is scheduled to start in three minutes, but sometimes this dentist starts on time and sometimes you end up waiting longer. You might be waiting thirty seconds, or you might be waiting for half an hour. This is the type of situation where Inflating the Investment can make you procrastinate. You might reason to yourself that if you start reading a book, you can hardly gain momentum. You'll end up stopping in the middle of a chapter, or maybe you'll not even get through one page. But if you check Facebook, you'll get instant gratification. You'll see updates from your friends, and you might even have some new likes.

However, if your dentist happens to get delayed and you end up waiting for thirty minutes, the two experiences become more and more different. If you're reading a book, you could wind up learning a great deal. If you're scanning Facebook, you'll more likely get a series of short snippets, all of which don't add up to much.

These are two very different results that, over time, can add up to a lot. The thing that keeps you from reading the book instead of scanning Facebook is Inflating the Investment. Reading the book feels like a big commitment. It feels

like you won't get much out of it unless you have a solid block of time. But you can scan Facebook for one minute, or you can scan Facebook for a couple of hours. So it's easy to choose Facebook over reading.

The breakthrough idea from Nick's ritual of laying out a pile of books was that he was completely reducing the commitment involved in reading a book. He could treat each book as you might treat a single post on Facebook: Check it out for a second, if it's interesting, investigate more. Otherwise, move on, guilt free.

For me, becoming a better writer involves reading a lot of books, so I was eager to try it myself. I started, like Nick, with a big stack of books in front of me. I'd read the table of contents of each one, making a mental note of which parts sounded interesting to me. Then I'd pick the most interesting-sounding chapter of all of the books and I'd scan the subheadings. If I got pulled in by the content, I'd keep reading. Otherwise, I'd move on to another chapter in another book.

By reducing my own sense of commitment in reading a book, I gave reading a fighting chance over Facebook when I had a moment free. Like many people, I had previously believed that if I picked up a book, I was somehow committing to reading the whole book. Or I'd think that I needed to start at the beginning, with the introduction. With my new relationship to books, I had complete permission to start wherever I liked and to put the book down if it wasn't interesting. I found that there were many little pockets of time throughout

my day when I could have been reading – yet I had been fill-ing those pockets with Facebook.

The same way those little pockets of time I was filling with Facebook would sometimes spiral into much longer, unproductive, and unsatisfying sessions, the little pockets of time I was filling with reading books grew into longer read-ing sessions that were both productive and satisfying. Over time, I grew from reading snippets of books to reading entire books. In the couple of years since I hijacked my Facebook habit with a book-reading habit, I've read more than a hun-dred books, I've collected thousands of interesting facts and stories that I use in my writing, and by reading lots of writing, I've improved my own writing. I still use Facebook, but just for a few minutes a day, and I'm easily able to stop because I'd rather be reading a book.

I've extended this method of mentally reducing the in-vestment to other parts of my work. If I have a moment free, I might pick up my phone and brainstorm some bullet-points of things I'd like to talk about with a podcast guest or what points I'd like to make in a blog post. By giving myself per-mission to make a small investment in my art, I sometimes build momentum and find myself drafting a whole blog post on my phone – especially if my dentist happens to keep me waiting longer than usual.

THIS ISN'T TO say that you need to quit using Facebook, or that reading books is necessarily productive for you, person-

ally. The point is that you have many little pockets of time throughout the day when you could start making your art. You don't have to be sitting at the easel or in the recording studio. You might be riding the train, standing in line, or waiting for a friend to arrive at the cafe. If you take the pressure off yourself and let yourself make a tiny start, you often make way more progress than you could have imagined.

If you have only a few minutes free, you can jot down notes about characters for your novel. You can beatbox a song into your smartphone. Even if you're a chef, you can make progress on your art while waiting. Simply Recipes founder Elise Bauer told me that she sometimes brainstorms flavor combinations in her own mind.

Watch out for times when you are Inflating the Investment. What low-commitment things do you end up doing instead of making your art? Change your perception of what it takes to get started. Your art will not only fill the tiny spaces in your life, it will expand and grow into a body of work.

I inflated the investment, in part, because I believed I had to read a book from start to finish. A similar mental distortion makes us think that we need to make our art in a linear progression. We'll cover this in the next chapter and discuss what to do about it.

THE LINEAR WORK DISTORTION

*All the best ideas come out of the process;
they come out of the work itself.*

—Chuck Close

A<small>FTER</small> I <small>SIGNED</small> my first book deal I didn't know where to start. I had this great opportunity in front of me, and a legal document binding me to a series of deadlines. After writhing in agony in front of my keyboard for a week or two, getting no usable writing done, I did the least logical thing I could have done: I booked a flight to Costa Rica.

I had been invited by my friend Noah Kagan, who had been employee number thirty at Facebook, employee number four at Mint (which later sold to Intuit for $170 million), and who was now founder of AppSumo. He and some other entrepreneurs were going on a retreat. They were all at various turning points in their careers and were taking time to evaluate one another's directions and decide what to do next.

I didn't have any trouble deciding what direction to take. After fleeing Silicon Valley and going through three years of

experimentation to reach this point, it was clear I wanted to write this book. But I hoped that getting away would give me some clarity and propel me through this crippling creative block. I remember looking at the balance of my bank account, then looking at the price of the plane ticket, over and and over for half an hour. I hoped it would be worth it, as I grimaced and hit the "buy" button.

It was a strange place for me to be so miserable. Everyone was strewn around the infinity pool amidst the calls of great-tailed grackles and capuchin monkeys. The ocean breeze tempered the warm sun. Chris, Ariel, and Aaron were jumping around in front of a computer playing a workout video. Mike and Matt were discussing a website design on the patio, and I was sitting inside, on what would normally be a comfortable couch, trying to write. My agony must have been written on my face, because when Noah stepped into the house with an iced tea, he asked, "Are you okay?"

"I'm trying to write this book," I said. "I can't even get started."

"What's your plan?"

"Well, the book is supposed to be about 55,000 words. I have five-and-a-half months left. So, that's like," I punched some numbers into a calculator app, "333 words a day?"

"How many words do you have so far?"

"Um. Zero." Noah lowered his glass and raised his eyebrows. "It's just so overwhelming," I continued. "Each word I write, I think about the million other words in the book

that might contradict or repeat it. I've gotta make this book happen. I've put everything into this."

Noah sat near me on the couch. "What about the blog posts that got you this book deal? Is this how you wrote those? You counted the *words* and then wrote them?"

"No. I guess I just kinda wrote them."

"Okay, but what did that look like? What were the steps?"

"Um...I guess I just kinda barfed them out. Then some time went by and I looked at them again. Then maybe I'd write an outline."

"Draft. Then outline. Then what?"

"Then I'd kinda go back over them and smooth them out."

"Draft, outline, polish. Break each chapter down into those three phases. Divide up your timeline. Put it on the calendar. Stick to the calendar. You're done."

"But...."

"Put it on the calendar."

"Okay."

"Dawg. You can do this." Noah stood up and walked outside to join the workout session in progress.

AT FIRST, I was resistant to Noah's advice. He made it sound so simple, as if I could count on making the writing happen on schedule. It wasn't just the words that had to be written, they had to be accompanied by visual examples and illustrations. Trying to break it down into a process felt like a game

of Whac-A-Mole. Every time I tried to put something on the calendar, I'd think of some other detail that would make that timeline impossible or unlikely, or it would open up some other unknown gap that I didn't know how to fill. Then again, it was a better plan than simply writing 333 words per day. So, I fought through breaking everything down into steps. I assumed I wouldn't follow it perfectly, but it would serve as a guide.

The next day, I sat at a desk on the interior balcony of the house and reviewed my calendar, which now had a series of milestones. I'd start with chapter three. All I had to do was write whatever I could think of for that chapter, then a few days later, I'd write an outline for what I had so far. After that, I'd polish it well enough to have a first draft to send to my editor.

As I tapped out those first few words on the keyboard, it was clear something had changed. I stopped worrying about how each word might relate to other words in other chapters of the book. Each time I started to worry, I'd remind myself I had an airtight timeline on my calendar. I knew that if I wrote today, I could make that writing better tomorrow, and I'd still be on schedule. I was free to create in the moment. On that balcony, with a view of the Pacific Ocean cheering me on through the wide-open glass doors of the house, I had my first effortless writing session. I had found my place in that book. I finally got started.

You might have noticed that my writing process wasn't

what you would expect. Growing up, whenever I was assigned writing in English class, I was always paralyzed by being assigned to write an outline *before* writing a paper. I always wondered, how are you supposed to decide what you're going to say before you actually say it? As I started to write more, I discovered that it worked better for me to write a draft first. Then I'd use that draft to write an outline, and I'd use that outline to write my final draft.

It wasn't until I wrote my first book that I realized my teachers had been pushing me into the Linear Work Distortion. It's easy to fall into the trap of expecting creative work to happen linearly, as if writing is as simple as putting one word after another, or as if painting is as simple as putting a brush to canvas. When we try to emulate the great work that inspires us, we follow this false progression and end up frustrated. It keeps us from getting started.

The Linear Work Distortion is the false belief that creative work is a neat, step-by-step process, wherein the final product steadily reveals itself. In fact, that's not how creative work really happens. It's often messy, and iterative.

JON BOKENKAMP, CREATOR of NBC's *The Blacklist*, has a nonlinear way of writing scripts. On *Love Your Work*, he told me that he starts with stream-of-consciousness writing. "I'll open a scratch file, and I'll just type to myself. And I literally will type in everything that comes into my brain. It's

kind of a dialogue with myself where I say, 'All right, what's the scene about?'"

If Jon comes across a good idea while typing, he types that idea in all caps. "I'll end up with three hundred pages of that, and I'll print it out and go through and with a highlighter mark the things that are worth keeping…. From that, it turns into note cards, and I lay them out on my floor into the three acts of a movie structure."

If you were writing a script for the first time the Linear Work Distortion might make you think that since a script mostly consists of dialog, you'd better start writing dialog. But that's not at all how Jon's process works. "The dialog is the end of the process", he says. "It's really about the story."

I got to the point where I had my first book deal through a messy process. I simply wrote what came to mind. I'd write stream-of-consciousness like Jon Bokenkamp does, then I'd cut it up and polish it into blog posts. It was far from an ideal process, but it did work.

As I was sitting uncomfortably on that couch in Costa Rica, I had lost sight of my nonlinear process. My first instinct was simply to divide up the length of the book into the time I had to write the book. It took Noah three seconds to see that I was falling for the Linear Work Distortion. I had to recognize the process that worked for me, and account for that process in how I'd manage the project. As I had expected, I didn't progress neatly from stream-of-consciousness to outlines to a first draft every step of the way. But knowing that

my plan accounted for my nonlinear process made me less anxious and freed me up to be creative.

AS YOU COMPLETE bigger and more sophisticated projects, you'll get to know your process better, and your process may change as a result. In fact, when we watch people with more experience than we have, this is why we fall for the Linear Work Distortion. We expect our process as a beginner to be like the process of a master.

One of Picasso's models recalled that, as she stood in her pose, he merely stared at her, without drawing a thing. After an hour, he said, "I see what I need to do.... You won't have to pose again." The next day, he began a series of paintings of her in that pose – entirely from memory. You could easily hear a story like that and conclude that Picasso was simply a master, and that there'd be no use in trying your hand at painting. But you'd be forgetting that Picasso was sixty-five years old, and had been drawing and painting day in and day out for decades at that point.

To overcome the Linear Work Distortion, get a feel for your process by creating whatever comes easiest to you. You already know that you should start small so the Fortress Fallacy doesn't hold you back. So you should be able to complete smaller projects without getting overwhelmed. As you learn the process that works for you, adapt that process to your plan of execution as you attempt larger projects.

If you iterate through the messy process of creating your

art, you'll get a clearer picture of where to start new projects. Inevitably, you'll find yourself battling with your internal critic along the way. In the next chapter, we'll learn how to quiet that critic to keep yourself moving.

PERMISSION TO SUCK

I'm frightened all the time. But I never let it stop me. Never!

—Georgia O'Keeffe

MAY 31, 2004. I was wrapping up another late night in my beige cubicle. The office was almost silent. The only sounds were the hum of fluorescent lights and my true self scratching against the shell of my ego. Staring into the mirror seemed to be working. Now that I had broken up with the person who liked to yell at me, I was determined to get out of Nebraska.

But how? Do I just sell all of my stuff and drive west? Do I hitchhike? Maybe I could walk? After sending resumes to companies around the country, it didn't look like there were any takers to pay the moving expenses of an entry-level graphic designer from Omaha. I had never met anyone who had done something crazy like move somewhere else with no job, where they knew no one. That type of thing was for people in movies. I'd talk about going for it once in a while, but whenever I did, people would remind me why it was a bad idea: I wouldn't have a job. I couldn't get an apartment

without a job. I couldn't get health insurance without a job. I was a long way from getting out of here.

I let out a deep sigh as I scrolled through the blog of Douglas Bowman, who would go on to become the lead designer at Google, then Twitter. Every pixel in his design was in place. His writing was clear and engaging. He had a calendar widget on the side of his blog, and everything was all organized into neat categories.

If I had a blog, I thought to myself, I could show my work to people around the world. Maybe I could get out of here. But just like I couldn't imagine packing a few things into my beige Camry and driving away, I couldn't imagine how I could make something like this blog. From where I sat at point A, point B may as well have been in a different iteration of the multiverse.

I didn't know how to get where I wanted to go, so I reached for the nearest hand-hold I could grab. I went to Blogger.com and opened an account. I couldn't think of a name for my blog, so I just called it "David Kadavy's Blog." I was tempted to delay by making choices such as which template I wanted to use, or whether or not I should allow comments, but I tried to keep myself driving forward. *Publish the first post*, I told myself. *Publish the first post.*

I opened a new post and stared at the blinking cursor in the blank box for a moment. I didn't know what to write. Each letter I typed set off a chorus of laughter in my ears. I was still telling myself to *publish the first post*. So I wrote what

came to mind. It's the worst post I've ever written, and it's the best post I've ever written:

> May 31st, 2004 – 8:16 p.m.: Okay, I'm finally trying out this blog thing. I don't really have any particular intentions for this blog, except to ramble (and perhaps inform) about design, web design and the like. I looked around and saw some very impressive blogs all organized into categories and I was pretty intimidated...only to find out blogger.com seems to make all of that pretty easy. I'm glad I decided to just jump into it. I have a tendancy [sic], when I'm learning something new, to try to take in every detail of something before I attempt it. The result is a sort of paralysis. So, since I don't know much about blogging yet, and it seems there is a decent amount to know, I'm just going to barf this out and clean it up later.

It's the worst post I've ever written for obvious reasons: It's a long, pointless paragraph. It has no useful information. It even has a misspelling. But it's the best post I've ever written, because it got me started. Without this post, I never would have written the next post, or the post after that, or the post after that.

This was the real beginning of my self-actualization. This was where I found the heart to start. A year after writing this post, I got a job at a startup in Silicon Valley, with my moving

expenses paid. Six years after writing this post, I got a book deal. None of that would have happened if I hadn't written this one blog post. None of that would have happened if I hadn't given myself Permission to Suck.

THERE'S A VIDEO you might have seen of Ira Glass, the creator of the hit radio show and podcast *This American Life*. He's sitting in a sound studio, cup of coffee in front of the sound board. He's just talking about his work. It doesn't seem like he's about to say something monumental that will inspire thousands of creators, but he does.

"All of us who do creative work...," he says, "we get into it because we have good taste.... But there's a gap – that for the first couple years that you're making stuff, what you're making isn't so good.... But your taste – the thing that got you into the game – your taste is still killer."

Throughout this third and final section of the book, we've talked about many ways that we fool ourselves into not starting. We dream of building a fortress when we should be starting with a cottage. We fool ourselves into procrastinating by exaggerating how much time we really need. We create mental blocks by imagining our work will follow a linear progression.

When you read my first blog post, you can actually see me fighting with all these forces. I felt intimidated by the great blogs I had seen. The vision I had in my head, like a fortress, was much bigger than what I was currently capable

of. Even though it was a late night at the office and I wanted to go home, I didn't procrastinate by exaggerating the time it would take to get started. In my mind, I had pictured that I would build a blog step by step, but I instead chose to "barf [it] out and clean it up later."

There is one final way that we prevent ourselves from starting, and it's the strongest and most dangerous force of all. It's perfectionism, and I'm so grateful I was able to overcome it in that moment. As I said, "I'm glad I decided to just jump into it."

Perfectionism is dangerous because perfectionism is a real "humble-brag" of a quality. When job interviewers ask candidates what their weaknesses are, many of them will smugly proclaim, "I'm a perfectionist." It feels good to believe you have high standards. It feels good to believe you have good taste. It feels good to believe that you won't sacrifice your dignity by doing sub-par work.

But oftentimes, perfectionism is what keeps us from getting started. As our ego cradles us in the warm blanket of our high standards, days and years melt by. We get ever closer to dying with our art still inside us.

If we never get started, we never get good, and you can't get good without first being bad. To overcome perfectionism and get started, you need to accept that your first attempts will not be up to your standards. You have to give yourself Permission to Suck.

When you give yourself Permission to Suck, you accept that your early work won't be up to your taste. You free yourself up to get moving. You remind yourself that it's okay if your first song or short story or painting isn't what you had pictured. You use that first piece as a starting point to build the next piece.

My first blog post sucked. My next blog post sucked. I have written dozens and dozens of sucky blog posts, and I can only hope that I will continue to do work that sucks until the day I die. Because it's in the process of doing that bad work that the good work comes out. Singer-songwriter Ed Sheeran said that he writes four or five songs a day when he's working on an album. He says, "if you turn a dirty tap on it's going to flow shit water for a substantial amount of time, and then clean water's going to start flowing." Hemingway had a similar philosophy. He said, "I write one page of masterpiece to ninety-one pages of shit."

JUST BECAUSE YOU'RE able to give yourself Permission to Suck one time doesn't mean you'll be able to do so in the future. Fighting perfectionism to finally get started is an ongoing battle. I first talked about starting a podcast way back in 2012. I was sharing an apartment in Buenos Aires with my friend Laura Roeder. We were taking a break from working on our laptops on the dining room table. In between sips of mate, I told her I was thinking of interviewing people like her about the unique businesses and lifestyles they had built.

"I think you should do it," she said. I then procrastinated for four years.

When I finally did interview Laura about founding one of her companies, a social-media-automation tool called Meet Edgar, she reminded me how much farther along I would have been if I had just given myself Permission to Suck. "If you're just thinking about doing a podcast for four years, you're not able to improve the podcast, you're not able to see what topics people like…. You don't know any of those things until you make it." She was right. While the first episodes of *Love Your Work* were bad, my only regret is that they could have been worse.

Part of what makes giving yourself Permission to Suck so powerful is the way that it uses your own perfectionism to your advantage. When you start off with bad work, the very fact that you started propels you to do better work. The basis of this trick is a motivational martial art that we'll cover in the next chapter.

MOTIVATIONAL JUDO

*Art is a lie that helps us
understand the truth.*

—PABLO PICASSO

AFTER RETURNING FROM the retreat in Costa Rica, thanks to Noah's advice I had newfound clarity on how I was going to finish writing my book. Each step of the process was on my calendar. Still, each day, I had to settle my creaky joints into a chair and get started. So I would lie to myself.

Each morning, I got out of bed, put on my slippers, and shuffled past my hissing radiator, across the hardwood floor to my desk. I set the timer on my phone for ten minutes, and I wrote.

I made a deal with myself: After those ten minutes were up, I could feel like I had accomplished something. If I was thirsty, I could drink. If I was hungry, I could eat. If I wanted to check email, I could check email. In the first ten minutes of my day, I had already gotten something done, so, I would tell myself, I deserved a reward.

The only condition was this: I had to write for that entire

ten minutes. If I was thirsty, I couldn't drink. If I was hungry, I couldn't eat. If I wanted to check email, I couldn't check email. Everything would have to wait for ten minutes. Everything would have to wait until that timer went off. Until then, I had to keep my fingers moving.

Here's why it was a lie: I almost never stopped at the ten-minute mark. Yes, those first moments were hard. I was fighting to quiet my internal critic to write a few words. Soon after starting, I would suddenly be thirsty, or I'd suddenly be hungry, or I'd suddenly wonder about an email I was expecting. Having made this simple deal with myself, I would deflect each of those urges and keep my fingers moving. When the ten minutes was up, I was no longer thirsty, I was no longer hungry, and I no longer wondered about email. I had gotten past resistance and gained momentum. The ten minutes I had promised myself turned into thirty minutes, an hour, or two hours of solid writing – all before breakfast.

I was using Motivational Judo to get myself started and to gain the momentum to keep going. One of the principles of the martial art of judo is that you use your opponent's energy against himself. If he comes charging at you with a punch, you can use that forward momentum to throw him over your shoulder. You can do the same thing with your ego. With Motivational Judo, you use the force of your own ego to kickstart your project and keep yourself moving.

AFTER WRITING *DESIGN for Hackers*, I collaborated with behavioral scientist Dan Ariely on a productivity app. We used Motivational Judo principles to help people be more productive. For example, we found that people were more likely to do something if they had it on their calendars. As Dan explained to me, "For people who use their calendars, it's quite a good tool. If you put things in their calendars, they'll do it, and if they're not in their calendars, they'll probably not do it." So, we created a feature called "Goals." You could set a goal – let's say you wanted to work on your novel three times a week. Our app would find times on your calendar for achieving that goal. It was a lot harder to skip out on working on your novel once it was already on your calendar.

Dan has done some fascinating research on cheating. The things he has learned about cheating can tell us a lot about how we cheat ourselves out of starting and why scheduling goals on a calendar would help people reach those goals.

In one study, Dan and his team gave participants puzzles to solve. They'd be paid based upon how they scored, so they'd be motivated to cheat on the puzzles, if given a chance. In one group, Dan and his team checked the answers of participants, and in another group, participants were allowed to check their own answers. What they found was, when given the chance to cheat by checking their own answers, many participants took advantage of the opportunity. In fact, just about everyone cheated when given a chance – though not by much. Dan said, "Rather than finding that a few bad apples

weighted the averages, we discovered that the majority of people cheated, and that they cheated just a little bit." Dan and his colleagues were even able to replicate these results around the world with no difference in the level of cheating, no matter what country.

The results of this study may make you cynical about humanity. You're probably convinced that, since you're an honest person, if you had been in these studies you would not have cheated. But the people in these studies probably thought the same thing. In fact, further studies suggested they had no conscious knowledge that they were cheating at all.

In another study, Dan and his colleagues found that participants truly believed that the scores they achieved through cheating were an accurate reflection of their skill. Participants were given a test that had a supplied answer key. Since they had the chance to cheat, as the previous study would have predicted, many participants cheated. But when they asked these participants to predict their performance on a future test, on which it was clear there would be no answer key, the participants predicted a similar performance. Even if they were paid for how accurately they predicted their performance on the future test, the participants predicted they would do just as well – even though they knew there would be no chance for them to cheat. They truly believed in their original scores, even though they had cheated.

These studies suggest that cheating isn't driven by a con-

scious desire to simply get more. Instead, we tend to cheat subconsciously. Through various studies, Dan and his colleagues have found that no matter how easy they make it to cheat, no matter how clear they make it to participants that they won't get caught, and no matter how much participants can gain by cheating, people still rarely cheat big. Instead, they cheat only a little bit. As Dan says, "We cheat up to the level that allows us to retain our self-image as reasonably honest individuals." It seems we cheat only up to the point that we can convince ourselves we're still good people.

IF YOU PAY close attention, you'll notice that you cheat yourself out of making your art all the time. Throughout this section of the book, we've seen it in action. We dream beyond our current skill level so we can convince ourselves we're not ready to start. We tell ourselves we don't have the time. We take pride in our identity as perfectionists. All these create valid reasons to not get started. All of these let us feel good about ourselves in the meantime.

This self-deception is driven by the conflict between the ego and the self. Remember that the ego is trying to protect us. It will convince us that we aren't procrastinating, while at the same time allowing us to reap the benefits of that procrastination. In the short run, we have to do less real work, but in the long run, we end up never starting.

This is why putting goals on someone's calendar helps that person achieve those goals. If you have to tell your app

that, once again, you aren't going to work on your novel, as planned, there's no hiding the fact that you are cheating yourself. That's why Goals worked so well it's now used by millions of people. The app that Dan and I were working on, Timeful, was bought by Google, and now Goals is a feature on Google's Calendar app.

If having Goals on your calendar is so powerful, and if I had milestones on my calendar for planning my book project, why did I still have to lie to myself each morning to get myself to write? This brings us to a subtle but important detail of the martial art of Motivational Judo: You have to apply just the right amount of force in your commitments. If you make too small a commitment, you won't gain enough momentum to keep moving. If you make too big a commitment, you'll just end up cheating yourself.

When I originally put milestones on my calendar, I tried to plan long daily writing sessions. I'd put a four-hour block of time on my calendar that said "writing." For my skill level at that time, that was asking too much. I couldn't even start a writing session without shuffling into my kitchen to make yet another cup of tea, or without checking my email again. To my ego, I had made an unreasonable demand. It was enough to cause my ego to trick me into thinking I was thirsty, or that there was an important email that I couldn't miss.

This is why my ten-minute timer was so powerful. Even if I felt thirsty or hungry, or if I felt an urge to check email, those urges weren't strong enough to take me off task. There

was a stronger force fighting back: my own need to see myself positively. I couldn't fail at trying to write for ten minutes – it would be too damaging to my self-perception. Even my ego couldn't come up with a reasonable excuse. By "lying" to myself by committing to ten minutes, I was able to gain enough momentum to make resistance melt away and to keep writing for much longer.

WHEN I INTERVIEWED L. David Marquet for *Love Your Work* he told me about a similar technique he used. When he started writing his book, he wasn't a writer – he was a retired U.S. Navy submarine captain. He would use Motivational Judo to start his writing sessions. David said, "If you say, 'I'm going to write for eight hours today,' it just makes your head explode." Instead, he would set a timer for twenty minutes. If he had gained momentum in that twenty minutes, he'd set his timer for another twenty minutes, then another twenty minutes. David explained, "You can do anything for twenty minutes. You can hold your breath for twenty minutes." Motivational Judo worked for David. He finished his book, and *USA Today* ranked *Turn the Ship Around* in the top twelve business books of all time.

Setting a timer to commit to a small work session is not to be confused with the "Pomodoro Technique," which usually involves working for twenty-five minutes at a time, separated by five-minute breaks. The purpose of Motivational Judo is to gain enough momentum that you don't need a

break. When you set a short timer as a Motivational Judo technique, the short time frame is merely a decoy to get the ego to take a lunch break. Pomodoro does work for some people, but honestly, if I needed a break every twenty-five minutes, I would take that as a sign that I needed to find a new line of work. If you're using curiosity as your guide in making your art, chances are you won't need frequent breaks either. Once you've gotten over starting resistance, the fuel you've found in the second section of this book should keep you moving.

Setting a timer for a short work session is just one potential Motivational Judo move. What works for you will depend upon what your ego does to protect your self-perception. I had to set a timer for ten minutes because that was the sweet spot for bypassing my ego. Apparently decades in the military gave David Marquet the discipline to make it through twenty minutes. Maneesh Sethi has a more extreme approach. He hired someone off Craigslist to sit next to him while he worked. If he got off task, she would tap him on the shoulder. If that didn't work, her job was to slap him in the face. It worked so well that Maneesh wanted to replicate this punishment without needing someone sitting next to him. He created a wristband called Pavlok, which he used to shock himself dozens of times a day.

I used Pavlok to help me break my bad Facebook habit, but it wasn't effective for getting me to write more. Whenever I tried it, my ego would too easily squirm its way out of

using it. I'd "forget" to wear it or to recharge it, or I'd change the rules I had set for myself. For me, Pavlok was a powerful tool for breaking a bad habit, but I also had the motivation of wanting to replace that habit with the healthier habit of reading books.

The right Motivational Judo move for Maneesh Sethi is the threat of punishment. The right Motivational Judo move for me and David Marquet is a ridiculously easy goal. To find the right Motivational Judo move for you, look out for how your ego protects you from starting your art. How can you use the need for a positive self-perception in a way that will give you momentum? Some methods will be too weak to get you going. Others will be so extreme that you can't get yourself to follow through. You have to find the sweet spot. Even if you find a Motivational Judo move that works for you, what works may change over time. Maneesh no longer shocks himself to stay motivated, David Marquet no longer needs to set a timer for twenty minutes to start writing, and these days, I rarely need to set a timer myself to get started.

As we've seen in this chapter, starting in a way that gains momentum is a great way to leave resistance in the dust. This is true at the moment your fingers touch the keyboard, or as your brush touches a canvas. But momentum is also important for getting you to the finish line. In the next chapter, we'll learn about how to start the whole project in a way that will give you the momentum to finish.

CRACK THE WHIP

When you find yourself in the thickness
of pursuing a goal or dream, stop only to
rest. Momentum builds success.

—Suzy Kassem

B Y USING MANY of the tricks in this book, you can ensure that when you start, you have the momentum to keep going. If you start with something you're curious about, you'll work harder than you would have otherwise. If you are attuned to a feeling of excitement for an idea, you'll pursue ideas with the fuel to keep you moving. If you search for the thing that will pull you through, you can get through the tough parts of the project. One final way to keep yourself going is to begin in the part of the project that will build momentum in other parts of the project.

Think about cracking a whip. If you get the technique down, the weight of the thick base of the whip will transfer throughout the rest of the whip. The whip will undulate, and momentum will build all the way to the tip. The tip ends up traveling so fast, it breaks the sound barrier. It's hard to be-

lieve, but that's why a whip cracks – it's traveling faster than the speed of sound. It's a miniature sonic boom.

There's no way you could move the tip of the whip that fast without this momentum. You'd have to be superhuman. But, with the help of momentum, it just takes a flick of the wrist to get that kind of speed.

It's the same thing with many projects. You can't begin with some of the tougher details in mind. Before you begin, it seems as if you'd have to be superhuman to bring a novel to completion – with difficult details like editing it, getting it typeset, and printing and distributing it. If it's your first time recording an album, you might not know the details of using recording equipment or mastering a track.

But when you approach these projects the way you would crack a whip, these harder details come more easily. You build so much momentum that you force yourself to learn the tougher parts because you're so excited about the power of the idea you've created.

THE FOUNDERS OF the hit game Cards Against Humanity were cracking the whip when they started. They were eight friends who were tired of all the board games they had played. They had played so many board games together that they had learned all the strange words in Balderdash and could no longer play the game.

So these eight friends started creating their own games. They made word-play games and improv-comedy games.

When they tried out one of their games at a New Year's Eve party, suddenly it seemed they were onto something. Co-creator Max Temkin told me, "The next morning we woke up and we were like, 'Wow, that was really funny.' Not just as an in-joke for us. People who didn't know us were laughing."

They wanted to share this game with the world, but they didn't want to go through the hard work and expense of getting it into stores. So they simply put a PDF of the cards they had created online. The game started spreading, but people kept emailing them. Anyone could download the cards for free, but people wanted to simply buy the game – they didn't want to go through the hassle of printing out and cutting cards.

With so much interest in the game, the friends could confidently work to make the game better and finally make it available as a product. They used that momentum to raise money on Kickstarter to fund the first printing of the game and to distribute it to their first customers.

It would have been easy for this group of aspiring game creators to have gotten ahead of themselves. They could have focused on how hard it would be to manufacture and distribute a game. If they had focused on these harder details too early, they would have worn themselves out. They also wouldn't have had that energy available to concentrate on what would really lead to their success – making a great game.

Instead, the Cards Against Humanity creators started with the part of the project that was easier for them. They

harnessed their love of fun games and used that to motivate them. The harder details of selling a game became easier because they knew people wanted to buy it. Max Temkin recalled his philosophy at the time: "I'm not thinking about this as a business person. I'm thinking about this as someone who just wants to contribute something to the culture. There's a joyfulness in that I can put this into the world, and it's making people laugh."

Thanks to their commitment to making people laugh instead of concentrating too early on the hard parts of manufacturing a game, Cards Against Humanity has become a cultural sensation. Chances are you've played it before. It's a set of black cards and a set of white cards. You combine the cards to make phrases that are strange, often hilarious, and always subversive. For example, a combination might be: "Here at the Academy for Gifted Children, we allow students to explore *not believing in giraffes* at their own pace."

Cards Against Humanity is consistently the best-selling product in Amazon's "toys and games" category. Even though they've avoided working with a distributor, which is usually a requirement for getting a product into big stores, Cards Against Humanity has built up so much demand, they were able to strike a deal to distribute directly to Target stores. Needless to say, they've sold millions of copies of the little cards they used to print out and cut by hand.

IN THE STORIES of the entrepreneurs and creators I've in-
terviewed for *Love Your Work* – people like Max Temkin of
Cards Against Humanity – I've seen many of them cracking
the whip.

Elise Bauer of Simply Recipes didn't worry about what it
would take to create one of the top recipe sites on the Internet.
She just posted her recipes one at a time. The site wasn't even
called Simply Recipes when she started – it was just her per-
sonal website. She didn't have a fancy content-management
system – she coded each page by hand. She worked with the
skills she had and the motivation to take her mind off her ill-
ness. Momentum built as her site grew in popularity.

Nick Gray, the friend who told me about putting a stack
of books in front of himself, cracked the whip when he start-
ed Museum Hack. He didn't start off worrying about how
to build partnerships to give museum tours in cities across
the country. He simply gave free tours to his friends, talking
about the pieces in the museum that he was excited about. It
wasn't until so many people were asking to go on his tours
that he finally had to start charging. It started with what Nick
could do easily, and the success helped motivate him to do
the harder parts later.

Jeff Goins, author of *Real Artists Don't Starve,* didn't
worry about all the details of writing a *Wall Street Journal*
bestseller. He started by writing on his blog for an hour each
day before work. His blog led to several books, each one

building momentum to write the next one, each one better than the last.

As I grilled James Altucher about how to start, he reminded me of my own path: "In your entire life," he said, "you never would have thought to yourself, 'I'm gonna quit my job right now, and move from Omaha, Nebraska, to Colombia and get [former AOL CEO] Steve Case on my podcast. Because it doesn't happen like that. You do things in little bits and pieces. You start off small, and you get bigger and bigger."

Even when I started *Love Your Work*, I was cracking the whip. Four years after I had shared the idea with Laura Roeder, I was sitting at a little desk in a bedroom I had rented for a month in New York's East Village. I got an email from podcaster Paul Jarvis's newsletter, talking about how easy and fun it was to have a podcast.

In that moment, I decided to finally begin. I didn't worry about finding the right name. I didn't worry about the technical details of distributing the audio files. Instead, I emailed my first guest, Jonathan Wegner, creator of the Timehop app, and set up a time to go by his office and interview him. Recording my first interview built momentum for me to figure out how to edit the audio, to find good intro music, and to come up with a name. It also turned out that Paul Jarvis's email was a bit of Motivational Judo for me: Making a podcast is certainly fun, but it's definitely not easy. I probably never would have started if I hadn't believed Paul's little "lie."

Telling someone to *just get started* isn't always enough.

As we've seen in this book, there are many forces that make that advice hard to follow. But, there is fuel you can find and there are mental barriers you can overcome to make it happen. That start can build the momentum for one explosive finish after another.

James Altucher was right. As I was staring in that mirror, I never would have predicted exactly where I'd end up going. The mere thought would have been too intimidating. I would have curled up in fear on my beige carpet. My little start of writing that first blog post in my cubicle was all the motivation I could muster at that point. But it built momentum for me to write another blog post, then another.

SEVERAL MONTHS AFTER writing that first post, I had built enough momentum that I took an entire week's vacation from my job, just to work on my blog. Having a living, breathing blog out in the wild was enough motivation for me to figure out how to redesign it, move it to its own server, and display my design portfolio to send around the world, looking for jobs.

I didn't know where this would take me, but having enough motivation to invest in taking my project to the next level was a whip crack in itself. As I searched for the next source of momentum, it dawned on me – this blog would be my own personal movie, with myself as the hero on a journey.

I carried my camera the two blocks from Farnam to Dodge Street. It was after midnight, so I was able to stand

in the middle of the busiest street in Omaha without getting run over. I dodged the passing cars, and stayed steady just long enough to snap a picture of the old plastic-letter marquee on the Dundee Theater. Back in my beige apartment, I contemplated what to call my movie. I Photoshopped new letters onto the marquee, and made it the masthead of my new blog design. The movie showing on my blog would be my own journey of self-actualization. I called it *Get to Know David Kadavy.*

EPILOGUE

*This is abundance. A luxury of place and
time. Something rare and wonderful....
We must do extraordinary things. We
have to. It would be absurd not to.*

—Dave Eggers, *A Heartbreaking Work of
Staggering Genius*

WE TEND TO think of creating a hit movie, opening a
restaurant, or building a nonprofit, as one start. The
reality is, you never stop starting. While I consider my first
real start to be publishing that little blog post from my beige
cubicle, there were many starts before it, and there continue
to be many starts well over a decade later.

Some starts – such as the book I tried to write when I
was ten – never became anything. Other starts – such as this
book – managed to see the light of day. Logically, I should
see those starts that led to finishes as more important. But
in reality, each start is important. Each start helped me learn
how to make the next start better. Each start gave me a better
chance at learning how to finish. Each start taught me a little
bit more of what I've shared in this book.

Understand that your art is a journey of self-actualiza-
tion. To create art, you have to blend your own personality,
experiences, and curiosities to make something uniquely

yours. To do this, you expose yourself to discomfort. You will have to live outside of the template that others try to set for you. You may fear judgment, or you may just simply find yourself procrastinating without even knowing that you're avoiding getting started. Your ego is there, distorting your thoughts to protect you from this discomfort.

To get started, you need to find the fuel to break through the gravitational pull of the ego. If you follow your curiosity, you will be able to work longer and harder than anyone else. Your curiosities may seem to take you off course, but when they converge, you'll be untouchable.

An explosive idea is powerful fuel for getting started. Ultimately, your work has to resonate with others. If you tap into the collective consciousness, others will immediately identify with your work. Fortunately, your own consciousness is a part of this collective consciousness. If you have the courage to listen to the voice inside your head, it will lead you to ideas that puncture the vacuum between the status quo and people's true thoughts and desires.

Remember that people will feel what you feel when you create your art. Be in touch with your own physical and emotional reaction to what you create. If it doesn't make you feel something, it won't make anyone else feel something. When you gear up to make your art, fuel yourself with the feelings that you want your audience to have for what you create.

In the journey of the many starts it takes to make your masterpiece, you will run across tough moments, or times

when something other than working on your craft feels more appealing. Try to identify what makes your work important to you. It will fuel you when nothing else can.

Even when you understand what holds your art inside you, and even when you can connect with the fuel sources that will get you started, you'll still face mental barriers that hold you back from starting. Remember that we tend to dream beyond our abilities. Don't let big dreams intimidate you into not starting, and don't let them lead you into burnout. Let your dream be your guiding star while putting one foot in front of the other.

No matter how busy you are, there are always little pockets of time when you can get started. If you let go of expectations of what you need to invest in order to begin, you can make tiny starts throughout your day. This is powerful, because by making those tiny commitments, your craft grows in importance amidst everything else in your life. One by one, little sources of wasted time and energy fall away.

When you face larger projects, you tend to expect them to be completed in a linear, step-by-step fashion. This causes a creative block, because it forces you to question each move you make. Recognize the messy patterns you follow in your smaller projects and adapt those patterns for your larger projects.

Perfectionism can hold you back from starting and make you procrastinate. This is especially dangerous because it feels good to think of yourself as a perfectionist. Just as we tend

to dream of projects beyond our current abilities, we tend to expect a higher level of quality than we're currently capable of. By accepting that your early work won't meet your standards, you can free yourself up for action. This freedom allows you to do the large volume of work required to get good at something, which, counterintuitively, leads to better and better work.

At the source of many of these mental distortions is the conflict between the ego and the self that's a natural byproduct of the journey of making your art. Be aware of specifically how your own ego allows you to cheat yourself out of making your art. Use those distortions to propel your work forward. It may be as simple as telling small "lies" to your ego, or you may be the type who is more motivated by big commitments with equally big punishments for failing.

Finally, each and every time you start, whether it's your first crack at a new craft, the beginning of a new project, or one of the many starts within a project, search for the best way to gain momentum. By finding the part of the project that is easy for you to do, but that will build momentum to do the harder parts of the project, you keep yourself moving – with more fun, and less pain – all the way to an explosive finish.

I truly hope that this book helps you start, even when it's scary, or when it feels like you just don't have the time. There's always something you can do instead of making your art. For you to find the heart to let it shine, you have to fight the

forces that keep your work inside you. Now that I've shared everything I've learned over the years, when you get that great advice that seems so hard to follow, you won't be asking yourself, "Yeah, but *how*?" It really is good advice, and now you're ready to follow it. So what are you waiting for? *Just get started.*

ACKNOWLEDGEMENTS

MAKING THIS BOOK a reality has been a circuitous journey, and there's no end to the people I could thank who have helped along the way. This is an even bigger group than it normally would be. Since I don't have the standard agent and publisher, tangible help comes from dozens if not hundreds of people. Here's my feeble attempt to include everyone.

Though a small part of my motivation in writing books comes from what I learn in the process, I ultimately write them for readers. So thank you first, to you, the reader.

I wouldn't have written this book if I hadn't had a clear picture of what I wanted to do with my life and work. The people with whom I went on that retreat in Costa Rica have played a huge part in that. We've now gone on three retreats, and I've left each one transformed into a sharper version of myself. Some iteration of the idea for this book came from our latest trip to Mexico. Thanks to everyone who has gone on those retreats: Brendan Baker, Ben Einstein, Matt Hodgson, Lee Jacobs, Noah Kagan, Chris Keller, Mike Manning, Daniel Scholnick, and Aaron White. Thanks to Brian Balfour and Ariel Diaz not only for their guidance on these retreats but also for making them happen. Thank you to my mastermind partner, Phil Thompson, for keeping me on track.

This book has ironically come from many false starts

and dead ends in the publishing process. Thanks to everyone who has shared their experiences in publishing: Robbie Abed, James Altucher, Nir Eyal, Seth Godin, Jeff Goins, Clay Hebert, Ryan Holiday, Bernadette Jiwa, Andrew Kroeger, Mark Manson, and Shane Snow.

Much of what I've learned and shared in this book comes from my conversations with my podcast guests on *Love Your Work*. Thank you to all of those guests, too numerous and growing to include here.

Love Your Work is made possible in part by *Love Your Work* Elite members who support me on Patreon. Thank you to Drew Ackerman, Arif Akhtar, Stacie Arellano, Chrissy Chavez, Brooks Erickson, Jill Fechner, Daniel Fisher, Julien Gantner, Renee Gross, Fernando Labastida, Matt Lacey, Rich Peterson, Kyle Ritchie, Ed Stanfield, and Christine Stone. (If you'd like to join these heroes, and get bonus content in return, visit lywelite.com)

I started writing this book publicly. Many people selflessly donated to help support that process. Thank you Vaidy Bala, Austin Cottle, Annie Darling, Brandon Dauphinais, Mark Effinger, Angel Gonzalez, Neil Hawkesford, Akanksha Joshi, Katie Lauffenburger, Peter Marcano, Aaron Michael, Andrew Miller, Julien Mourer, Kirk Musngi, Olena Mutonono, Boy Nils Schulte am Hülse, Steve Norris, Devon Ostendorf, Nora Peterson, Ram Ravisankar, John Stromme, Nati Tessema, David Thompson, Adam Vermeer, Jeff Wikstrom, Grazyna Wilk, and Michael Wilke.

Many early readers of this book provided editorial feedback. Thank you Vaidy Bala, Lucy Barber, Tony Bieda, Andrew Broman, Alex Buchanan, Mary Campbell, Cyndi Casey, Louis Chew, Bob Crume, Mark Cutts, Jared Dees, Jade Edward, Cheryl Hulseapple, Christina Kennedy, Esti L, Colette Lachapelle, Alice Maldonado, Helen Miller, Idahosa Ness, Ketakee Nimavat, Dana O'Dell, Tim Ong, Sridhar Rajendran, Joseph Ross, Mickey Schafer, Traci Scherck, Carol Schmitz, Sam Shennan, Ed Stanfield, Kimberly Thornton, Elizabeth Velasco, and Adam Vermeer.

Thank you to Ana for helping me disconnect, and to the people of Colombia for letting me live in their country. It's a great place to write.

NOTES

Prologue

My conversation with author and entrepreneur James Altucher was on episode 53 of *Love Your Work*. http://kadavy.net/blog/posts/james-altucher-podcast-interview/

Carol Dweck's research on mindset shows us that your ability to learn new things depends upon whether you have a "growth" mindset or a "fixed" mindset. See her book, *Mindset: The New Psychology of Success.*

Chapter 1

My conversation with Jon Bokenkamp, creator of NBC's *The Blacklist*, was on episode 93 of *Love Your Work*. http://kadavy.net/blog/posts/jon-bokenkamp-the-blacklist-interview/

Chapter 2

I originally learned the story of Helen Keller from Mark Beeman and John Kounios's *The Eureka Factor: Aha Moments, Creative Insight, and the Brain.* I later captured more details from Keller's *The Story of My Life.*

My conversation with Jodi Ettenberg, a former lawyer turned food and travel writer at *legalnomads.com*, was on episode 23 of *Love Your Work*. http://kadavy.net/blog/posts/jodi-ettenberg-2/

Chapter 3

My conversation with Sean Stephenson, Osteogenesis Imperfecta survivor, author, and motivational speaker, was on episode 73 of *Love Your Work*. http://kadavy.net/blog/posts/sean-stephenson-interview/

My conversation with Ryan Holiday, author of *Ego Is the Enemy*, was on episode 31 of *Love Your Work*. http://kadavy.net/blog/posts/ryan-holiday-podcast-interview/

Steven Pressfield presents his groundbreaking concept of "Resistance" in his book *The War of Art*.

Chapter 4

My conversation with Ian Leslie, author of *Curious: The Desire to Know and Why Your Future Depends On It*, was on episode 95 of *Love Your Work*. http://kadavy.net/blog/posts/ian-leslie-interview/

The story of Steve Jobs dropping in on the calligraphy class is from his commencement address at Stanford in 2005. The full transcript is here: https://news.stanford.edu/2005/06/14/jobs-061505/

You can witness my excitement, and screenshots from the launch day of *Design for Hackers*, on my blog: http://kadavy.net/blog/posts/d4h-is-here/

Chapter 5

I first encountered the "vacuum" that helps things go viral in Seth Godin's *Unleashing the Ideavirus*. It's available for free download here: http://sethgodin.com/ideavirus/

Maya Angelou talked about how much it pleased her when people told her they *wrote* her books in an interview in issue 116 of *The Paris Review*. I sourced it from a collection of such interviews, a book called *The Paris Review Interviews, IV*. It's also available for paid subscribers here: https://www.theparisreview.org/interviews/2279/maya-angelou-the-art-of-fiction-no-119-maya-angelou

After deciding to invest in myself instead of buying a house in Nebraska, it was several years before I wrote *The Best Investment You Can Make* in October 2008: http://kadavy.net/blog/posts/the-best-investment-you-can-make/

I created a "support" button, which takes the form of a "thumbs up," much like Facebook's "like" button, in a Facebook app I made called Through a Friend, conceived in November 2007 and released circa February 2008. It had a similar functionality to the "like" button in that it sent a piece of content through the social graph to friends and friends-of-friends. I tweeted a screenshot here: https://twitter.com/kadavy/status/917589147983818752. TechCrunch reported Facebook's release of the "like" button on February 9, 2009: https://techcrunch.com/2009/02/09/facebook-activates-like-button-friendfeed-tires-of-sincere-flattery/. When I discovered this and shared my surprise on Facebook, Justin Rosenstein, the credited inventor of the "like" button, chimed in with, "Ha, don't believe I ever saw that Support button, but props to David – great minds, or something :-)" (https://www.facebook.com/photo.php?fbid=10156661633410744&set=a

.75020880743.99904.505765743&type=3&theater). Which is my point. I don't claim to be the first person to think of making a "like" button. In the above TechCrunch article, they even cite a now-dead link to a demo video from the now-defunct social network FriendFeed in which a "like" button was reportedly featured a month before Facebook's release, which was before FriendFeed was able to implement the feature themselves.

I first conceived of a food photo-sharing app, later to be known as nom.ms, on May 15th, 2009, while tweeting a photo at brunch at Orange, on Clark Street in Lincoln Park, Chicago. I built it in a "Django Dash" hackathon with some developer-partners, and we launched on June 16th, 2009 (http://kadavy.net/blog/posts/introducing-nomms-tweet-what-you-eat/). I had a conversation with Foodspotting co-founder Alexa Andrzejewski when we both spoke at the Webprendedor conference in Santiago, Chile, in 2011. When I told her about the app we had built, Alexa was surprised, because when she started Foodspotting in August of 2009, she was certain no such thing existed (Crunchbase shows the founding date of Foodspotting as September 1, 2009).

Since I'm working so hard to "prove" these timelines, I want to stress again that in none of the above cases do I feel that anyone "stole" an idea, or that I even would have been equipped to have the same success as any of them. The point is that many people are thinking the same thing at the same time.

I learned about Charles Wheatstone and Samuel Morse simultaneously inventing the electric telegraph in *The Victorian Internet: The Remarkable Story of the Telegraph and the Nineteenth Century's On-line Pioneers*. Swan and Edison's simultaneous inventions of the incandescent light bulb, and the simultaneous invention of calculous by various mathematicians, are from the Wikipedia page on multiple discoveries: https://en.wikipedia.org/wiki/List_of_multiple_discoveries

Chapter 6

My conversation with Andrew Johnson, creator of the "Relax" app, was on episode 19 of *Love Your Work*: http://kadavy.net/blog/posts/love-your-work-episode-19-relax-andrew-johnson-on-building-an-app-empire/

Chapter 7

J. K. Rowling's "rock bottom" quote came from her 2008 commencement address at Harvard University. Full text here: https://news.harvard.edu/gazette/story/2008/06/text-of-j-k-rowling-speech/

My conversation with Elise Bauer, creator of *Simplyrecipes.com*, was from episode 33 of *Love Your Work*: http://kadavy.net/blog/posts/elise-bauer-interview/

My conversation with author and entrepreneur Seth Godin was from episode 77 of *Love Your Work*: http://kadavy.net/blog/posts/seth-godin-podcast-interview/

Chapter 8

My conversation with Hugh MacLeod, founder of Gap-ingvoid, was from episode 61 of *Love Your Work*: http://kadavy.net/blog/posts/hugh-macleod-interview/

I learned about Evel Knievel's ongoing promise of jumping across the Grand Canyon from the book *Evel: The High-Flying Life of Evel Knievel: American Showman, Daredevil, and Legend*, by Leigh Montville.

Chapter 9

My conversation with Elise Bauer, creator of *Simplyrecipes.com*, was from episode 33 of *Love Your Work*: http://kadavy.net/blog/posts/elise-bauer-interview/

Chapter 10

My conversation with Jon Bokenkamp, creator of NBC's *The Blacklist*, was on episode 93 of *Love Your Work*. http://kadavy.net/blog/posts/jon-bokenkamp-the-blacklist-interview/

The story of Picasso painting a model from memory, as told by Françoise Gilot, is in David W. Galenson's book *Old Masters and Young Geniuses: The Two Life Cycles of Artistic Creativity*.

Chapter 11

The famous Ira Glass quote about taste is from a video on storytelling he did with Current TV. Current is now defunct, but the video has been republished in various

places, this being one of them: https://www.youtube.com/watch?v=X2wLP0izeJE

My conversation with Laura Roeder, CEO of Meet Edgar, was on episode 9 of *Love Your Work*: http://kadavy.net/blog/posts/laura-roeder-podcast-interview/

Singer-songwriter Ed Sheeran's "dirty tap" analogy is from the livestreamed interview with Jake Harries ("JacksGap") he did from YouTube's London headquarters: https://www.youtube.com/watch?v=0Z7blockquoteL4vBCU

I found Hemingway's "ninety-one pages of shit" quote in a letter he wrote to F. Scott Fitzgerald, which appears in the book *Ernest Hemingway on Writing*, edited by Larry W. Phillips.

Chapter 12

My conversation with Dan Ariely was from episode 51 of *Love Your Work*: http://kadavy.net/blog/posts/dan-ariely-interview/

Dan's research on cheating, as well has his "few bad apples" and "retain our self-image" quotes, are from his book *The Honest Truth About Dishonesty: How We Lie to Everyone – Especially Ourselves*.

My conversation with L. David Marquet, author of *Turn the Ship Around*, is from episode 89 of *Love Your Work*: http://kadavy.net/blog/posts/l-david-marquet-interview/

Maneesh Sethi shared his experience of hiring someone to slap him, then later building Pavlok, on episode 13 of *Love*

Your Work: http://kadavy.net/blog/posts/love-your-work-ep-isode-13-your-weakness-is-your-superpower-w-maneesh-sethi/

Chapter 13

My conversation with Max Temkin, co-creator of Cards Against Humanity, was on episode 45 of *Love Your Work*: http://kadavy.net/blog/posts/max-temkin-podcast-inter-view/

My conversation with Elise Bauer, creator of *Simply-recipes.com*, was from episode 33 of *Love Your Work*: http://kadavy.net/blog/posts/elise-bauer-interview/

I learned about Nick Gray's story of starting Museum Hack from my conversation with him on episode 11 of *Love Your Work*: http://kadavy.net/blog/posts/love-your-work-ep-isode-11-hack-hidden-value-w-nick-gray-of-museum-hack/

Jeff Goins told me about how he started writing on epi-sode 27 of *Love Your Work*: http://kadavy.net/blog/posts/jeff-goins-podcast-interview/

My conversation with author and entrepreneur James Altucher was on episode 53 of *Love Your Work*: http://kadavy.net/blog/posts/james-altucher-podcast-interview/

The newsletter from Paul Jarvis that prompted me (through a "lie") to finally start podcasting: https://us6.cam-paign-archive.com/?u=26857d08cfc91db6993e0bfc4&id=b1259b5893&e=14d3c9a7bf

ABOUT THE AUTHOR

DAVID KADAVY (@KADAVY) is a bestselling author, blogger, podcaster, and speaker. Through his blogging at *kadavy.net* and his podcast, *Love Your Work*, he helps people find satisfaction through following their crafts, even if it takes them down unconventional paths. David's writing has appeared in *Quartz, Observer, Inc.com, The Huffington Post, McSweeny's Internet Tendency*, and *Upworthy*. He has spoken in eight countries, including appearances at SXSW and TEDx. He lives in Medellín, Colombia.